Images of Modern America

RIVERCHASE

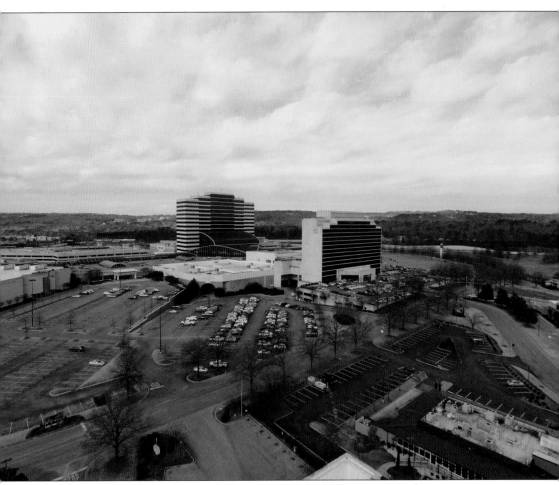

AERIAL VIEW OF RIVERCHASE GALLERIA, 2015. In 1975, one of the biggest announcements during the Riverchase development was made jointly by John M. Harbert and Claude Morton Jr.: a $30-million, 850,000-square-foot mall on a 70-acre site on the northwest corner of Highway 150 and Highway 31. The mall, now known as Riverchase Galleria, was opened in February 1986 by developer Jim Wilson & Associates. The Riverchase Galleria complex also includes Galleria Tower and Hyatt Regency at the Wynfrey. (Robin Schultz, bluffparkdrone.com.)

FRONT COVER: In March 1993, much of Alabama was covered in snow. Spencer Rogers, age six, is shown bundled up in front of his family's Riverchase home. (Spencer Rogers)

UPPER BACK COVER: This is modern-day Riverchase Parkway; the original sign, made of wood, was later replaced with this one and updated landscaping. (Christ the King Lutheran Church)

LOWER BACK COVER (from left to right): Meghan and Caitlin Carey pose at the original Riverchase sign before the big game (Carey family); Mimi Batten and Sophia Manley are on a mission from Riverchase United Methodist Church in 2015 (Riverchase United Methodist Church); unidentified ladies are ready for tee time in the 1980s (Riverchase Country Club)

Images of Modern America

RIVERCHASE

Heather Jones Skaggs

ARCADIA
PUBLISHING

Copyright © 2016 by Heather Jones Skaggs
ISBN 978-1-4671-1740-1

Published by Arcadia Publishing
Charleston, South Carolina

Printed in the United States of America

Library of Congress Control Number: 2016936938

For all general information, please contact Arcadia Publishing:
Telephone 843-853-2070
Fax 843-853-0044
E-mail sales@arcadiapublishing.com
For customer service and orders:
Toll-Free 1-888-313-2665

Visit us on the Internet at www.arcadiapublishing.com

"In joining with Equitable we will build a new community offering a pleasant way of life for the people in this area. Riverchase will provide its inhabitants with a new experience in living: one in which trees, grass and flowers are just as important as buildings and parking places."

—John M. Harbert III
President, Harbert Construction Corporation
Johnson-Rast & Hays Company promotional mailer

CONTENTS

ACKNOWLEDGMENTS

On a sunny afternoon, I met with a group of Riverchase residents at Riverchase Country Club to discuss the possibility of this book. Attending that meeting and helping me along the way were Nance Kohnen, Lynne Cooper, Johnny Morgan, Sue Doleys, Jeanne Barelare, Linda Carey, and Terry Hooks. Over the last year, I have met, emailed, and talked with many people who have memories of Riverchase. Thank you to Bryan Chace, who helped me in many ways and allowed me to use photographs from his family collection. Thank you to Martha Storm; Mayor Frank Skinner; Jake White, cofounder of CartoTracks; Shelby County Historical Society and Museum; Shelby County Mapping Services; Riverchase Country Club; Riverchase Women's Club; Riverchase Residential Association; Morgan VonBehren, City of Hoover Park and Recreation; Hoover mayor Gary Ivey and the Hoover City Council; and Lori Salter, who always gets me where I need to go. Thank you to James Coker, Jefferson County Emergency Management Agency; Nick Derzis, Hoover Police Department; W.P. Gresham, Hoover Fire Department (retired); and Gerald Smith, Hoover City Building Inspection (retired). Thank you to the Riverchase churches who worked with me to include their histories in this book. Thank you to the Facebook group "Riverchase Neighborhood Family" for allowing me to post and ask questions. Thank you to Jamie Sandford and Spencer Rogers. As always, I have to thank my wonderful husband, Greg, who always helps me; my baby bear, Carrie; my mom and dad; Aunt Fran; Uncle Jim; Kay and Keith Milam; Rosemary and Tony Skaggs; and Hunter and Meg Jones for their support. Thanks to my new nephew Jaxon—someday, I will write a family history for you. I am sure I have left someone out, so to all who have helped, I say thank you.

INTRODUCTION

Before we can journey through the modern history of Riverchase, we must first turn back the clock to a time before the major development. Before Riverchase was the community it is today, it was called Acton. The mines scattered along the Cahaba River brought the coal industry to Jefferson and Shelby Counties in Alabama. Major players in the business of mining came to the area, including Truman H. Aldrich, Daniel Pratt, and Henry Fairchild DeBardeleben. Hoover, where Riverchase is located, is on top of a large coal bed named the Cahaba coalfield. On page 12 of this book is a map outlining the different coalfields in Alabama. The Acton Basin (the general area where Riverchase is located) is over eight miles long and five miles wide, according to the Hoover Historical Society. The Acton family owned much of the land in the basin and was involved in mining coal near the river. According to the obituary of Zephaniah William Henry Acton (1834–1920), the Actons were the first to mine coal in Jefferson and Shelby Counties. The Acton mines were in the southernmost mining villages within the family's property, and records show them as operational going back to 1906. Unfortunately, they were also some of the most dangerous mines. There is much to discuss surrounding the Acton mines, but that is another book.

In 1945, the Tennessee Coal, Iron & Railroad Company, which bought the Acton land from the family, sold the land to three brothers—Bryan August, F. Arthur, and George W. Chace.

The Chace family was active in Acton for around 18 years. In 1968, they sold their land to Harbert Construction Company, which marked the beginnings of Riverchase, as the Chace land accounts for a large portion of what is now Riverchase. The Chace brothers later sold another part of their land to the Hoover Athletic Association to build a ball park. The property where Chace Lake Country Club once sat was owned by the Chaces until the club's members bought both the club and the property from them. The property assembled by the Chace family was called Chace Acton Coal Properties. Surviving Chace family members harbor a reasonable belief that there was a strong desire to include "Chace" in the name of the community, or at least to reference it in homage. One of the meanings of "chase" (note the different spelling) is "an area of unenclosed land used for hunting game." With the Cahaba River being a prominent feature of the property, the name Riverchase came naturally to the founders. All area references to Chace Lake, roads, and Chace Lake Country Club use the family's spelling.

John M. Harbert III (1921–1995) founded Harbert Corporation with his brother B.L. Harbert (1923–2010) as well as other corporations bearing his family name. Originally from Mississippi, John M. Harbert enrolled in Auburn University's School of Civil Engineering, graduating in 1946. Auburn's John M. Harbert III Engineering Center is named after him. Harbert was a noted philanthropist who donated to many projects in Alabama. Often called a risk-taker and an entrepreneur, he demonstrated those traits in business. Birmingham's skyline served as a canvas for Harbert's designs. Two of the tallest buildings in downtown Birmingham—Regions-Harbert Plaza (formerly AmSouth-Harbert Plaza) and the Wells Fargo Tower (formerly SouthTrust

Tower)—were constructed by Harbert in partnership with Brice Building Company. Part of Interstate 459 is named for the Riverchase builder. Harbert also saw a need for a meeting place in downtown Birmingham for civic organizations, so he had The Harbert Center built. In the late 1960s, Harbert started to consider an idea for a planned community; he purchased the Chace land in 1968. Still Hunter, who later became the first project manager for the development of Riverchase, was the lead planner and negotiator for Harbert.

The man with the plan, John Harbert, won many awards throughout his career, including the Marketing Man of the Year in Alabama in 1967 and the Erskine Ramsay Award in 1976. In 1984, Harbert was named Citizen of the Year by the Alabama Broadcasters Association and became the first Alabamian to be ranked in the Forbes 400 listing of the richest Americans, a list he joined again in 1994. Harbert's obituary notes that he was also a man of great charity and compassion, spending much of his time working with civic and charitable organizations. He served as a member of the Boy Scouts of America's executive committee and gave millions in contributions to institutions of higher education, including Auburn University, Birmingham-Southern College, and the University of Montevallo. Many recall the fundraising drives Harbert held for the Eye Foundation Hospital, Birmingham Museum of Art, the YWCA, and countless others.

Harbert was a man with vision who saw tremendous potential for the beautiful piece of property and mined it himself for a time. He began planning Riverchase for two large tracts of land, and in 1974, the Harbert Corporation partnered with Equitable Life Assurance Society of the United States to form the Harbert-Equitable Joint Venture. Together, they developed 3,000 acres that had once been used for mining. Numerous articles from the *Birmingham News* and the *Hoover Sun* expand on the plans for the joint venture. Harland Bartholomew & Associates did the master plan, and Roger Yanko was the project manager and landscape architect. Construction moved quickly once the initial plans were complete. Riverchase Parkway opened in 1975, and the first home was completed in 1976. Riverchase was one of the few environmentally and architecturally controlled communities being built in the Southeast at the time—and the only one in Alabama. Developing a community in this way was new, and according to a statement by Equitable Life in a *Birmingham News* article from May 1978, "it was their most successful development." In 10 years, it was expected to be a $500-million development with 15,000 residents; the development ended up exceeding that number. The overall plan for Riverchase was to create an environment where people could work, live, and blend in with the surroundings and countryside while enjoying and preserving the natural beauty of the area. The developers wanted residents to live with nature, not just build on top of it.

The theme, so to speak, for construction in Riverchase was "building with, not against, the land." The development gave greater attention to better use of the land through the master plan, even down to each individual home, while working with the topography of the wooded and mountainous area. The streets in both residential neighborhoods and commercial districts are laid out to fit the natural landscape of Riverchase, not fight it. Development also came with restrictions to control tree loss and signage.

There are three sectors of Riverchase: the Country Club Sector, Riverchase West Sector, and the Dividing Ridge Sector. Homes built in Riverchase were each unique but followed two key guidelines that affected the neighborhood's outward appearance. First, trees and landforms were kept intact as much as possible, even in the spaces between homes and streets. Second, side-entrance garages were used to maintain overall curb appeal. Houses are also set back on their lots as far as 60 feet in some cases, with undisturbed areas of woods and lush nature providing desired privacy. Another effort to enhance curb appeal placed a focus on materials and colors rather than strict architectural style. Each home was compatible with the one next to it without giving the neighborhood a "cookie-cutter" feel. Houses are visible through trees and behind natural land contours, so these are not just streets lined with houses.

The plan also called for areas for businesses and corporations. Johnson-Rast & Hays was chosen as the sales agent in charge of residential and commercial sales for Riverchase. Companies such as John Harland Company and Oscar Mayer were some of the first to come to Riverchase. Allstate

Insurance, Western Electric, and Harbert Corporation also built home offices in Riverchase. Blue Cross Blue Shield of Alabama built its headquarters in Riverchase for an estimated $20 million and is still located off Riverchase Parkway. The South Central Bell data center also came to Riverchase, occupying a 50-acre site. Riverchase Country Club followed quickly thereafter.

Riverchase Country Club, the centerpiece of the community, has been nestled in the Riverchase community since 1976. In 1987, the club's members purchased it from the Harbert-Equitable Joint Venture, and it now operates as a full-service, member-owned club. Joe Lee created the initial design for the 18-hole golf course, which opened in 1976. The first player to tee off on Riverchase's course was professional golfer Gene Sarazen, who is one of only five golfers to win all current major championships during his career. The course underwent renovations designed by Denis Griffiths in 1989, and the plan was finished by John LaFoy the following year. The club also has 15 tennis courts, a Junior Olympic–sized swimming pool, a state-of-the-art fitness center, and dining opportunities featuring both fine and casual cuisine. Many celebrities—and even presidents—have teed off at Riverchase Country Club, including Pres. Gerald Ford, Michael Jordan, Bob Hope, and Charlie Boswell. Today, the course measures 6,842 yards with spectacular views of the mountains, rolling hills, and lakes. Riverchase Country Club has the distinction of being selected to host the Charlie Boswell Celebrity Classic, US Open qualifying, Alabama State Amateur Championship, Alabama State Four-Ball Championship, US Mid-Am Qualifying Tournament, Alabama Senior Amateur, Women's Southern Golf Association Championship, SEC Women's Championship, Women's Alabama State Amateur Championship, and Junior Golf Championship.

Not long after the development of Riverchase began, talks of annexation became a hot topic, even with a plan of Riverchase one day becoming its own city. The three choices for Riverchase boiled down to going into the cities of Pelham or Hoover or incorporating itself into its own city. A Pelham plan never really got off the ground, and start-up costs for a new city and issues with incorporation legislation made the latter unlikely. By 1979, discussions were underway between the Harbert-Equitable Joint Venture (via Riverchase project manager Leo Morehouse) and Hoover mayor John Hodnett and the Hoover City Council, which included councilman and future mayor Frank Skinner. It was a complex annexation partly dealing with the unknown. The Galleria had not yet been constructed but was a known factor in the equation; this was uncharted water, and Riverchase was the first planned urban development of its size in Alabama. One of the issues that needed to be worked out in the agreement was a sewer treatment plant. Part of the agreement, for example, stated that rates would never be higher than Jefferson County's rates. In a complex annexation, this was only one of many things to iron out. Also, per the community's covenant, annexation into a city before January 1, 1986, was restricted without the consent of the residential association (the developer and property owners). The Harbert-Equitable Joint Venture was willing to give its OK to go forward if owners voted to do so in an annexation election, which they did, and Riverchase was annexed into the city of Hoover in September 1980. Becoming part of Hoover had challenges but many positives for the Riverchase community and many benefits for the city. Riverchase's fire department merged with the Hoover Fire Department and gained higher-paying jobs and lower fire insurance rates (going from a class 7 to a class 5). City garbage collection replaced the private firm that had been working in Riverchase. The annexation also meant more police protection, as the Hoover Police Department added three new officers when Riverchase was annexed. Hoover gained its highest source of tax revenue, Riverchase Galleria (among other great additions), by annexing Riverchase. Clearly, the annexation of Riverchase sparked tremendous growth in Hoover's residential and commercial sectors.

Regarding that once-unknown factor in annexation, the Riverchase Galleria (also called Riverchase Mall) was first announced in 1975 and is now undoubtedly a major focal point in Hoover. Dubbed the "biggest, fanciest enclosed retail center in the state" by the *Hoover Sun* in October 1975, the galleria was developed by the Rouse Company (General Growth Properties) and Jim Wilson & Associates. Riverchase Galleria opened in February 1986 with four anchor stores: Parisian, Pizitz, Rich's and J.C. Penney. In March 1987, Macy's opened the company's first location in Alabama. The Riverchase Galleria complex also includes Galleria Tower and Hyatt

Regency at the Wynfrey. During construction in the mid-1980s, part of the complex caught fire, making news headlines and setting back construction. The 30-year-old carousel was taken down for a makeover in 2013, and the carousel's fabric top was replaced by lighted fabric streamers. The fountain that once ran where the carousel stands is gone, and the carousel now sits level with the floor instead of on the support system that covered the fountain. Today, General Growth Properties and Jim Wilson & Associates each own 50 percent of the complex, with General Growth assuming management control. This property, which was not part of the Chace family property, was owned by the Sherwood Stamps family.

Researching this book made it easy to see why Riverchase is a community of people passionate about where they live. Kids who grew up in Riverchase often choose to start their careers and families close to home. Many current adult residents were kids who grew up in Riverchase. The community—through its churches, country club, and residential association—has developed into a sought-after area to settle down, start a family, and even retire. There are so many events and activities available in which Riverchase residents can participate, fellowship, and grow. Neighbors often form lifetime friendships, and memories are made with each holiday.

Welcome to Riverchase, Alabama.

One

AN OVERVIEW
LAND HISTORY AND DEVELOPMENT

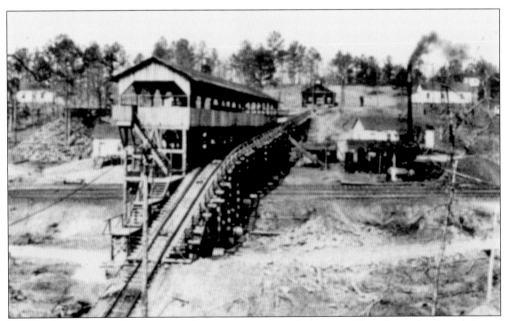

BEFORE RIVERCHASE. Years before the community now known as Riverchase developed, it was the site of the mining-company town of Acton. Henry DeBardeleben's Alabama Fuel & Iron Company established four mines in Acton around 1905 or 1906. After DeBardeleben died in 1910, his son Charles took over the business. Pictured here is Acton Mine No. 4, Riverchase's predecessor. (Shelby County Museum and Archives.)

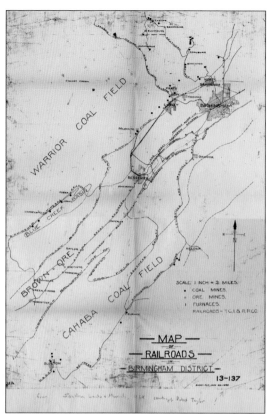

ALABAMA COALFIELD MAP. The Acton mines are located in the Cahaba Coal Field, which is shown here on an early map. The field runs through St. Clair, Jefferson, Shelby, and Bibb Counties over a total of about 360 square miles. During the Civil War, most of the coal supplied to the Confederacy came from those counties (plus Tuscaloosa and Walker Counties). (Birmingham Public Library Archives.)

COAL WASHER. The new Alabama & Tennessee River Railroad provided access, and the Cahaba field became the primary source of coal for the Confederacy in the area. Acton's success came from efficient coal production. Acton had a washer that removed impurities from coal mined in the basin. Pictured is the coal washer from Acton Mine No. 1. Note the Louisville & Nashville (L&N) boxcar. (Hoover Historical Society.)

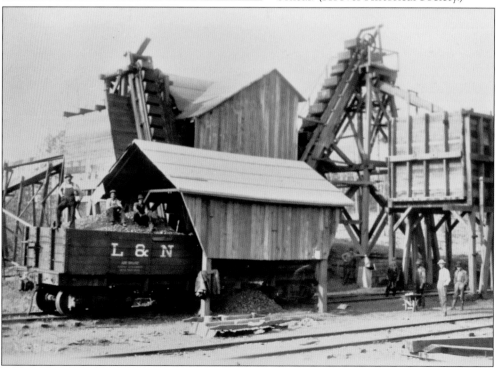

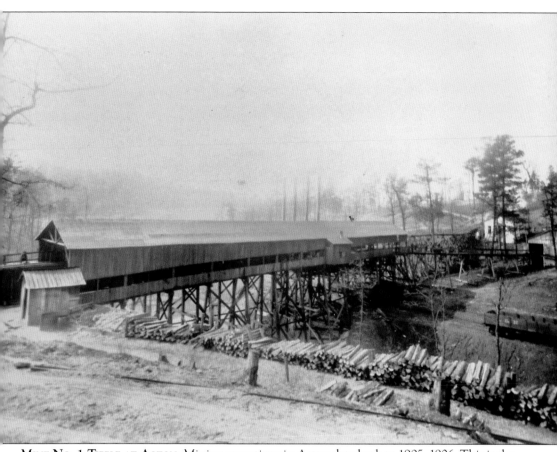

Mine No. 1 Tipple at Acton. Mining operations in Acton date back to 1905–1906. This is the Mine No. 1 tipple, which spans the railway spur to allow for dumping into cars. The Acton family owned much of the mining land in Acton, where they lived. Rev. William Acton was a minister in the Presbyterian church. William and his son, Zephaniah William Henry Acton, were both involved in mining operations. (Hoover Historical Society.)

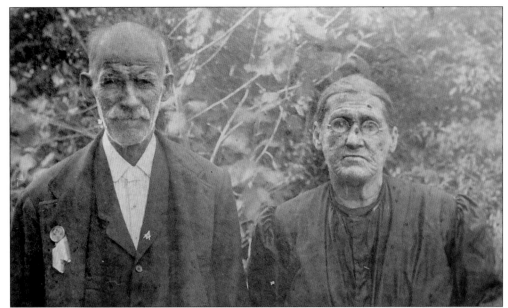

A GLIMPSE OF THE ACTON FAMILY. Shown here in the early 1900s are Zephaniah William Henry Acton and his wife, Passey Drusilla Watkins Acton. Acton Memorial Church (now Altadena Valley Presbyterian Church) was named in honor of Zephaniah, a charter member and founder of the church. Their children were James Dudley, Pleas Wiley, Stephen Vincent, Elizabeth Drusilla Acton Duke, and George Acton. (Hoover Historical Society.)

FAMILY CEMETERY. The Acton family cemetery is located behind Altadena Valley Presbyterian Church off of Caldwell Mill Road. This cemetery is owned by the Acton family and is commonly called the Rev. William Acton Cemetery. Both Zephaniah William Henry and Passey Acton are buried in this cemetery; their headstone bears the inscription, "Friend to the poor." (Author's collection.)

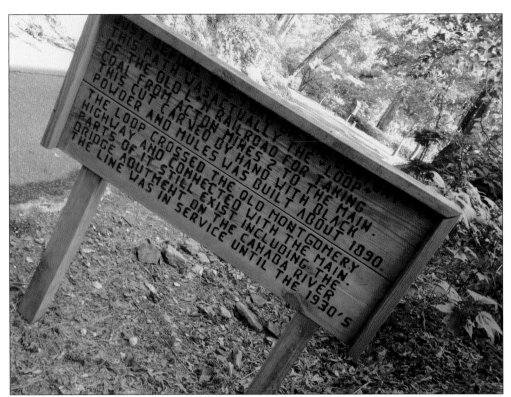

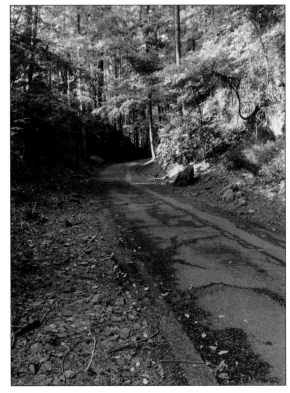

YESTERDAY AND TODAY. This sign marks a path at Riverchase Country Club that chronicles some of the area's mining history dating back to 1890. In the mining days of Acton, this path served as the loop on which the Louisville & Nashville Railroad transported coal from Acton Mine No. 2. According to the sign, the path was "carved by hand with black powder and mules." The line was still in service until the 1930s. The path, now paved, serves as a golf-cart road twisting through the natural hills and curves of the country club and residential areas. (Both, author's collection.)

THE CHACE BROTHERS. Bryan A., F. Arthur, and George W. Chace became fully engaged in land acquisition and management in the 1960s, after the sale of their Birmingham business, Chace Rubber Company. Pictured below are Bryan A. (left) and F. Arthur Chace at the Chace Rubber Company in Birmingham in 1930. Pictured at left is George W. Chace. The brothers bought the Acton property that was later sold to John Harbert. Bryan A. Chace maintained an office, located in the middle of what is now Riverchase, that was an old scale house where coal trucks would come to be weighed. At the time, there were only a couple of mines still operating in the area. Bryan A. Chace served as principal contact and trustee for the sellers of the Chace property. (Both, courtesy of Bryan Chace.)

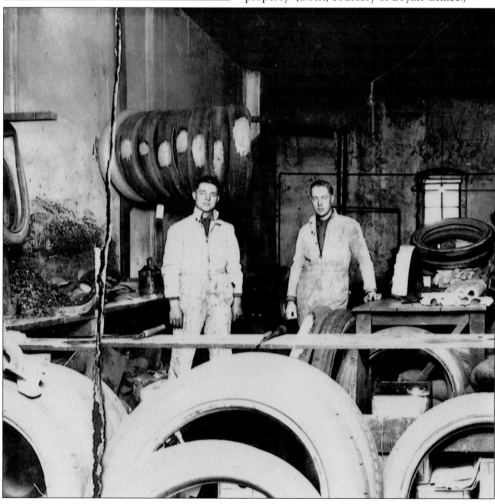

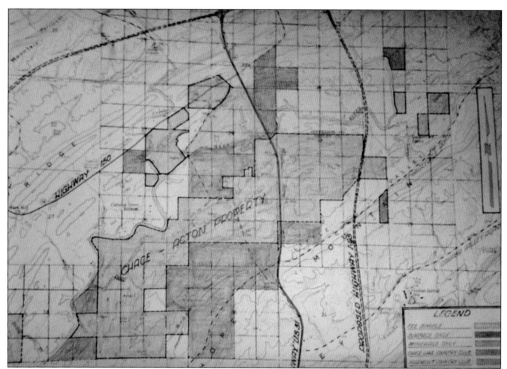

VINTAGE MAPS. The Chace family map above shows the property prior to development. The legend shows Interstate 65 and Chace Lake Country Club in the shaded orange "proposed" stage. The 1974 aerial map below offers a good view of Riverchase before development. In this photograph, above the handwritten "2," are a few mining roads. The main road in this map is Old Montgomery Highway. Note the two curves at the top. To the right of the first curve would be Riverchase Baptist Church, and the second curve is the current location of Riverchase United Methodist Church. The wider area in the road south of the first curve is where the current main entrances for Riverchase are on both the west and east sides of Old Montgomery Highway. (Above, Bryan Chace; below, Shelby County Mapping Services.)

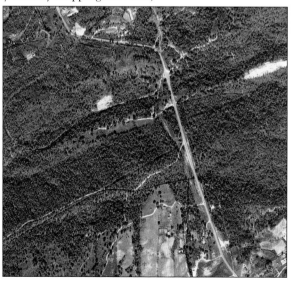

THE MAN WITH THE IDEA. John M. Harbert III was a noted philanthropist, risk-taker, entrepreneur, and graduate of Auburn University. He founded his Harbert Construction Corporation in 1946. One project in which Harbert Construction was involved in the 1960s was the Elton B. Stephens Expressway. During this time, Harbert also started to consider the idea of a planned community, which culminated in the creation of Riverchase. The Riverchase community was planned as a joint venture of Harbert Construction Corporation and the Equitable Life Assurance Society of the United States. The $500-million plan, which would take 10 years to develop, was formally announced in 1974. By 1975, the plans had been presented to the public. Harbert is pictured here at his initiation into Auburn's chapter of the Omicron Delta Kappa honor society in 1990. (Auburn University Libraries Special Collections and Archives.)

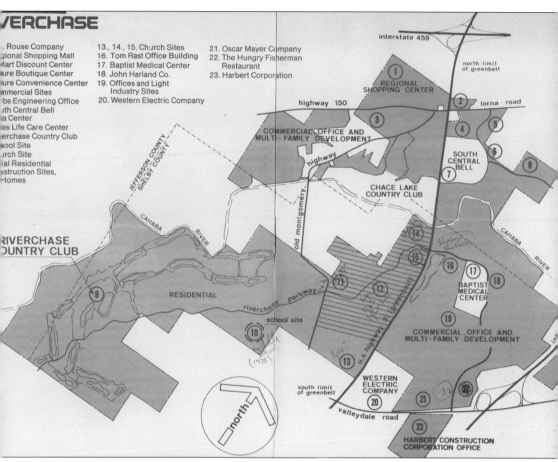

FORMAL ANNOUNCEMENT. What a local newspaper dubbed "new Cahaba town" was formally announced on a Tuesday in 1974 at a luncheon in the Birmingham Civic Center Exhibition Hall. The development's official name, Riverchase, referred to the 3,000-acre town with about half of its acreage in Jefferson County and half in Shelby County; Riverchase is divided by the Cahaba River and Highway 31. Henry Smith, board chairman of Equitable Life, and John Harbert, president of Harbert Corporation, presented the plans. At the time, Equitable Life was the world's ninth largest corporation. The master plan for Riverchase was prepared by Hartland Bartholomew & Associates and Johnson-Rast & Hays Company. Pictured is the inside of a promotional handout from the late 1970s outlining Riverchase and proposed locations for businesses, churches, and residential areas. (Christ the King Lutheran Church.)

VIEW OF RIVERCHASE PARKWAY THEN AND NOW. As work progressed through the Harbert-Equitable Joint Venture, the town started to take shape. Churches, businesses, and residents began buying lots. Pictured above around 1977 is Riverchase Parkway at its intersection with Highway 31. Note the original "Riverchase" sign in the middle of the photograph and the lake at left. Pictured below is the modern Riverchase sign. (Both, Christ the King Lutheran Church.)

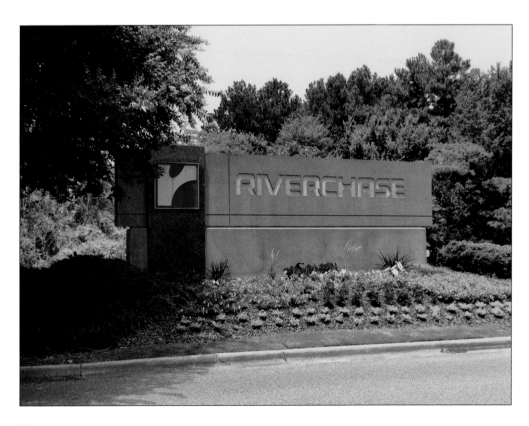

THE MAIN THOROUGHFARE. Road construction for the residential section of Riverchase began in the 1970s around the golf course, and utilities were installed for the entire property. One stipulation the developers made regarding Riverchase stated that no strip-mall commercial property would be allowed along Highway 31. The vision was to keep this major thoroughfare a beautiful tree-lined parkway. This late-1970s photograph offers a view looking across Highway 31 toward Riverchase Parkway from the future site of Christ the King Lutheran Church. Much has changed at Riverchase since this picture was taken, but the beauty and vision are still there today. (Christ the King Lutheran Church.)

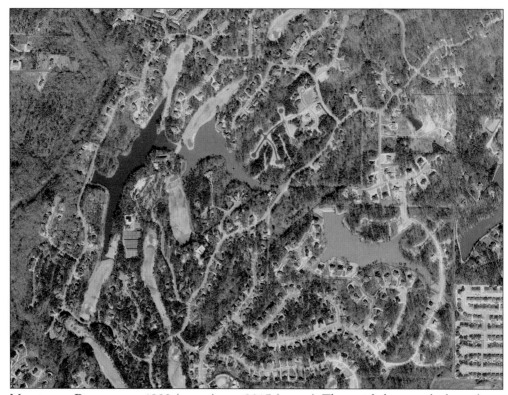

MAPPING OF RIVERCHASE, 1993 (ABOVE) AND 2015 (BELOW). The aerial photograph above shows Riverchase in black and white as it looked in 1993. The development of Riverchase's residences was divided into three sectors: the Country Club Sector, Riverchase West Sector, and Dividing Ridge Sector. The 2015 full-color digital map below shows the same section of Riverchase with the country club at center. This modern image displays the scope and greenery of Riverchase. Much (if not most) of Riverchase is in Shelby County, and the Shelby County Mapping Services division developed this digital map. (Both, Shelby County Mapping Services.)

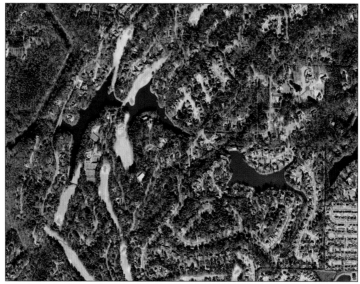

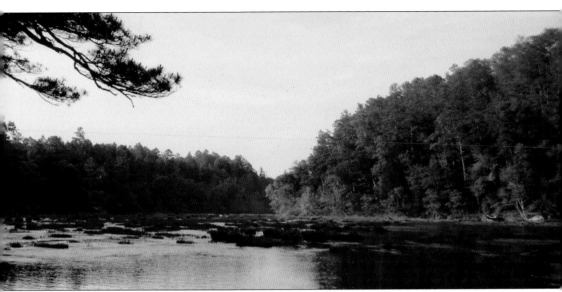

WONDROUS NATURAL SURROUNDINGS. The Cahaba River flows through Jefferson and Shelby Counties and right through the heart of the state of Alabama. The river attracts many canoeists and kayakers and is open for fishing, rafting, and bird-watching. The Cahaba is the longest free-flowing river in the state and has a wide diversity of plants and fish in its ecological makeup. The river runs right through Riverchase and rolls through the Riverchase Country Club Golf Course. The Cahaba River is one of the beauties of Riverchase and its community. (Both, courtesy of Sam Calhoun.)

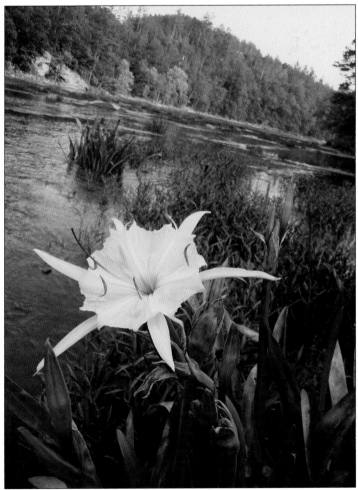

IT IS NOW RIVERCHASE. The differences between these two Riverchase entrance signs—located at the intersection of Old Montgomery Highway and Riverchase Parkway, where Riverchase Baptist Church is located—represent a time of development. While journeying through the modern history of Riverchase, it is important to remember that Riverchase is more than land and roads. It is a community and a family that has grown but stuck to its roots and kept the original vision alive. In 1979, it was apparent that Riverchase would likely be incorporated into the city of Hoover. Discussions between John Harbert; Leo Morehouse, Riverchase project manager; and John Hodnett, then-mayor of Hoover, included the annexation of the total Riverchase area, including all that was in Shelby County. Riverchase was annexed into the city of Hoover in September 1980. (Above, Riverchase Women's Club; below, author's collection.)

Two

EDUCATION AND FAITH
PART OF THE PLAN

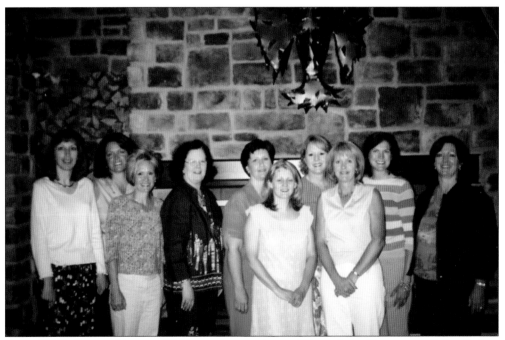

FIRST PTO. Pictured here in 2004 are the members of Riverchase Elementary School's first parent teacher organization (PTO). From left to right are (first row) Jennie McWherter and Pres. Yvonne Segrest; (second row) Janet Dees, Susan Filippini, Donna Bagwell, Dianne Baggett, principal Alice Carter, Sheila Norton, Anne Marie Wilson, and Melinda King. (Riverchase Elementary School.)

Riverchase Elementary School

Designed for the Success

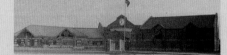

of All Students

Ribbon Cutting Ceremony
October 24, 2004

RIVERCHASE EDUCATION. Before the annexation of Riverchase into the city of Hoover, kids in Riverchase attended county schools like Valley Elementary. After annexation and several years of growth, it was clear that Riverchase needed a new area school. The above image shows Riverchase Elementary School under construction in 2003–2004. The new school, which educates students from kindergarten through fifth grade, opened under Supt. Dr. Connie Williams. Before the school opened, teachers and faculty were given a private tour of the nearly-finished school. Many teachers were able to prepare their classrooms several weeks before the school opened. Riverchase Elementary opened with 510 excited students ready to explore their new place of learning. With the exception of some new area residents, the majority of students transferred from Trace Crossings Elementary. This helped reduce the student population of that school to a more favorable size. (Both, Riverchase Elementary School.)

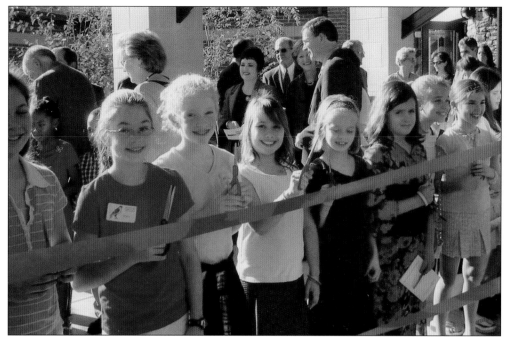

GRAND OPENING. Pictured here are Riverchase Elementary students ready to cut the ribbon at their new school on October 24, 2004. The ribbon-cutting symbolized the opening of Hoover's 16th school, which had officially opened in August 2004. In attendance at the celebration were Hoover mayor Tony Petelos and State Senator Jabo Waggoner. (Riverchase Elementary School.)

GOING STRONG. Ten years later, Riverchase Elementary is one of the top schools in the Hoover School System. Pictured here are parents and students enjoying the school's Fall Festival in November 2015. (Teth Lee.)

COUNTY SCHOOL CHANGES. Riverchase Middle School opened in 1977 in the Shelby County School System and was a feeder to Pelham High School. Pelham established an independent school system in 2014 with several changes. In February 2015, the Pelham Board of Education sold Riverchase Middle School for $4.25 million to Shades Mountain Christian School, a private institution. A new middle school is planned to open in Pelham in fall 2017. (Author's collection.)

BERRY MIDDLE SCHOOL. Today, Riverchase students go to Berry Middle School, part of the Hoover City School District. The middle school opened at the old Berry High location in 1994, when the new Hoover High opened that school year. Berry Middle remained in that location until 2006, when students moved to the new campus adjacent to Spain Park High School off Valleydale Road. (Author's collection.)

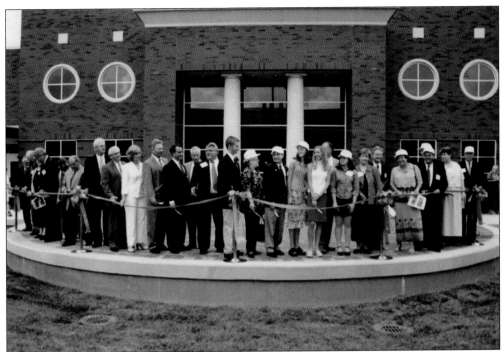

JAGUARS. As Hoover grew, it was inevitable that a second high school would be needed. Hoover purchased land from Birmingham on Valleydale Road to construct its new high school, Spain Park. The new high school opened in 2001 and adopted the jaguar as its mascot. Pictured here are students, faculty, and Hoover officials at the ribbon-cutting ceremony for the new school. (Hoover Board of Education.)

NEW METHODIST CHURCH. Riverchase United Methodist Church held its first worship service, with 77 people, on June 22, 1980, in the Blue Cross Blue Shield building. Dr. J. Conrad Willmon was appointed the church's first pastor. This church mailer from its early years invited residents to visit at the Blue Cross location. In 1991, the church began construction on a new building on six acres off Old Montgomery Highway. (Riverchase United Methodist Church.)

RIVERCHASE UNITED METHODIST CHURCH TODAY. In 1991, the church broke ground for its new 22,000-square-foot sanctuary, and in 1992, Wednesday night dinners and the Riverchase Day School began. In the late 1990s, the church added a contemporary worship service, and in 2005, a new Christian life center was dedicated. In 2014, the Children's Ministry created its own mission week for kids. During the summer months, kids in grades three through five participate in Marvelous Mission Week. The kids pick off-site mission projects around the city to help others and further the gospel. Pictured below are, from left to right, Coleman Gray, Hansen Lister, Grace Trewhella, Ret Trewhella, Mimi Batten, and Sophia Manley. The church's mission sites include Urban Ministry in West End, Turkey Creek Nature Preserve, University of Alabama–Birmingham Hospital, and Community Kitchens of Birmingham. (Both, Riverchase United Methodist Church.)

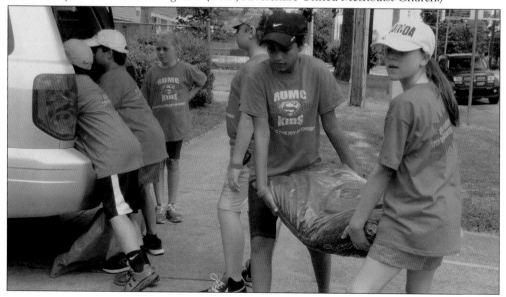

RIVERCHASE CHURCH OF CHRIST. This congregation, located in the North Shelby County area of Riverchase, began holding worship services in what is now its family center in 1979. Pictured here is the original sign for the church. In 1990, the church moved into its new auditorium. Riverchase Church of Christ is still in its original location on Montgomery Highway (Highway 31). (Both, Riverchase Church of Christ.)

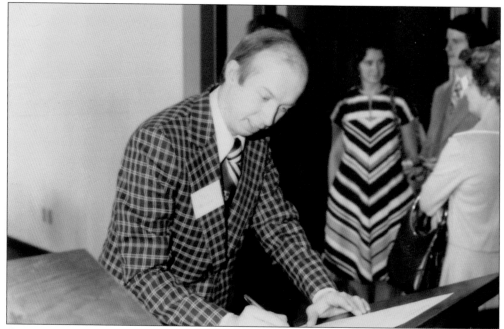

CHRIST THE KING LUTHERAN CHURCH IN RIVERCHASE. In 1975, the Lutheran Church in America saw the opportunity to start a new congregation in the area. Pastor J. Richard Gantt negotiated with the Harbert-Equitable Joint Venture for property in the developing Riverchase community. The first worship service for this congregation was held at Greentree Apartments Clubhouse in 1977. Rev. Thomas A. Dudley was installed as the first pastor of Christ the King Lutheran in September 1977. Pictured above is Tom Nelson signing the church's charter on March 27, 1977. Below is the ground-breaking ceremony, which was held on October 8, 1978. Over the next few months, services continued to be held in various locations until the church's construction was finished. (Both, Christ the King Lutheran Church.)

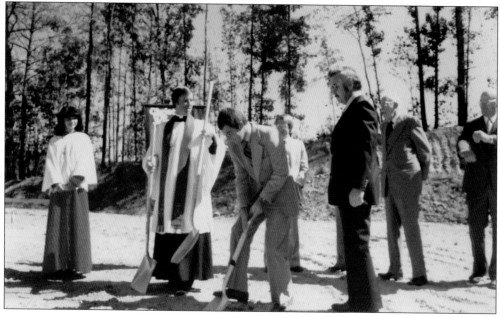

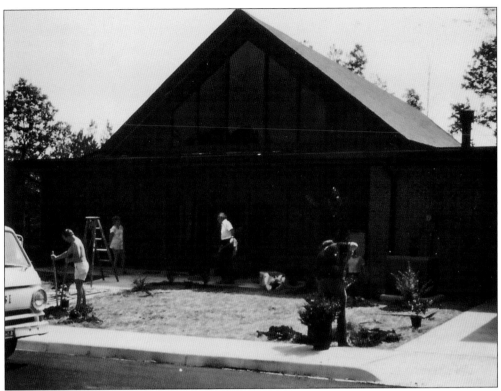

FIRST SERVICE. As construction neared an end, the Christ the King Lutheran Church building was almost ready for its congregation. Members helped put the finishing touches on the landscaping. Pictured below in 1979 is the first service in the church's new building. (Both, Christ the King Lutheran Church.)

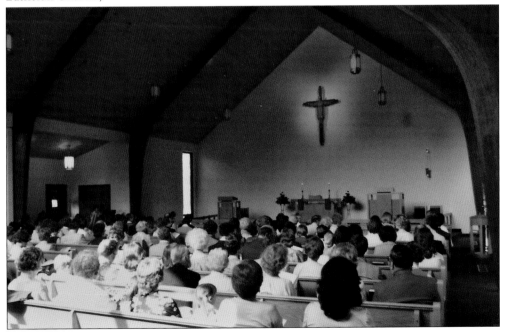

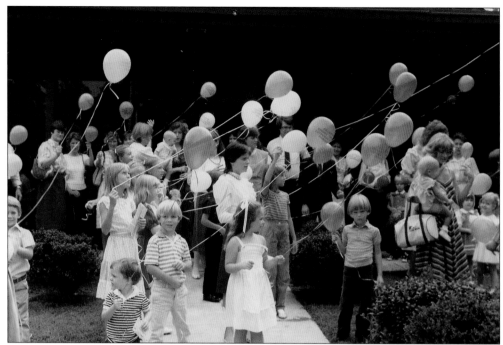

SUNDAY PICNIC. Pictured here are children and families at the annual Sunday Picnic, where they release balloons. Each balloon says "Celebrate Christ the King, Riverchase." An area adjacent to the church, simply called the "Hole," was full of trees, vines, and underbrush. The east end of the Hole featured an area with benches and an altar for outdoor services. In 2005, the Hole was cleared and filled with dirt to the parkway level to prepare for a large parking lot and a new building (below) housing the fellowship hall and student areas. (Both, Christ the King Lutheran Church.)

RIVERCHASE COMMUNITY CHURCH. This church began as Birmingham South Church of God in June 1980 with around 47 members who met at Green Valley Elementary School on Sundays. Within a productive and speedy six months, by 1981, the church had taken an option on some property in Riverchase near Valleydale Road. Dr. Tom Trick served as chairman, and William Anderson was called as the church's first senior pastor. Pictured below singing at the first service, held in Green Valley Elementary School, are, in no particular order, Masina Hawkins, Lisa Hawkins, and Karen Taylor, with Marci Hutto on piano and Lucy Fridley as accompaniment. April 1981 brought the church to a new, temporary location on Valleydale Terrace, and in May of that year, the congregation held its first meeting on the property where it would build its new church and changed its name to Riverchase South Church. (Both, Riverchase Community Church.)

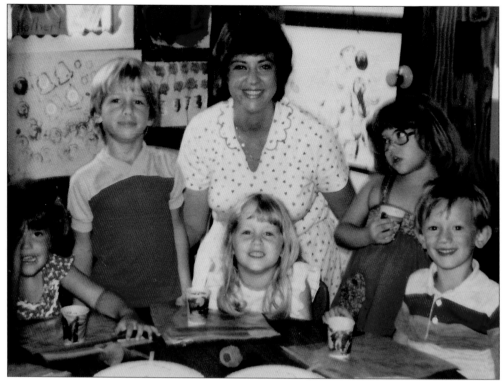

FIRST VACATION BIBLE SCHOOL AND EASTER AT RIVERCHASE SOUTH CHURCH. Among the happy campers pictured above at the first Vacation Bible School, held in 1981, are Matt Anderson, Kay Trick, Megan Turner, and Sam Raines. Below, Riverchase South's first senior pastor, Wayne Anderson, tells the Easter story during a Holy Week service in 1993. (Both, Riverchase Community Church.)

MISSIONS, RECREATION, AND TODAY'S CHURCH. Pictured above in the 1990s are students from Riverchase South Church's Youth Group as they prepare packages and literature for Brother Bryan Mission and Honduras. Riverchase South participates in church league basketball each year. Shown in the 1993 team photograph below are, in no particular order, Don Dupree, Wayne Anderson, Harold Cooley, Stan Hunter, Howard Megill, Reece Portwood, Landon Walls, and Kasey Fikes. Today, the church is known as Riverchase Community Church. Its vision remains to glorify God through worship, evangelism, fellowship, outreach, discipleship, and stewardship. (Both, Riverchase Community Church.)

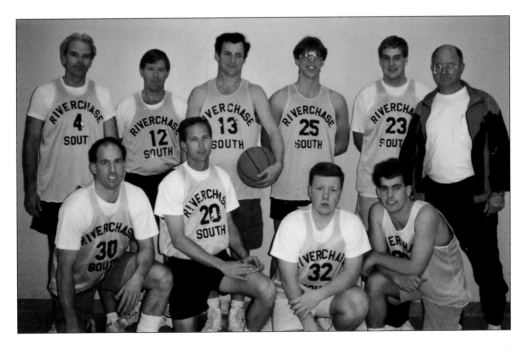

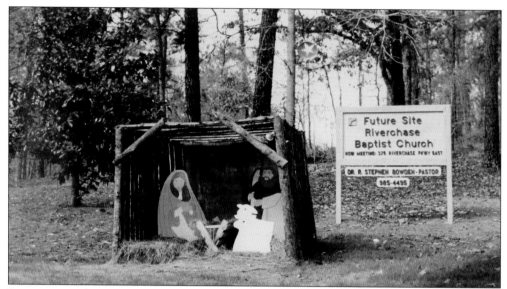

BAPTIST MISSION FINDS HOME. In 1985, Riverchase Baptist Fellowship was formed and began meeting in a classroom at First Baptist Church of Pelham. Outreach was key for the small group, so it placed flyers in mailboxes and made phone calls throughout the new community. On January 5, 1986, the Riverchase Baptist Mission formed; Dr. George Allison became the mission pastor that same year. Dr. Steve Bowden then served as pastor for 18 months. The congregation continued to meet at Baptist Medical Center at Riverchase until it was ready to build its own church on a six-acre site on the corner of Riverchase Parkway West and Old Montgomery Highway that had been purchased several years earlier by the Alabama Baptist State Convention. Pictured below at the ground-breaking ceremony are, in no particular order, Keith Smith, Kathy Smith, Charles Tittle, Barbara Tittle, Carol Dyar, and Steve Dyar. (Both, Riverchase Baptist Church.)

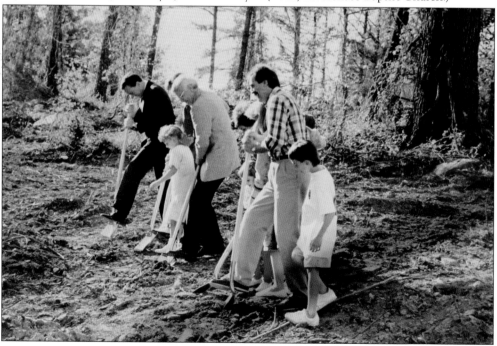

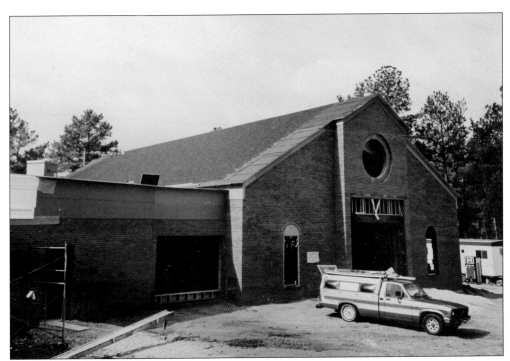

RIVERCHASE BAPTIST CHURCH
BUILDING, 1990. William "Buddy"
Nelson was called to become the church
pastor in 1989, and under his leadership,
the church's vision became a reality
when it moved into its new building
in 1990. Phase II of the building's
expansion included additional Sunday
school space, remodeling of the existing
building, and adding parking and a
second entrance to the property (off
of Old Montgomery Highway). The
members and pastors of this church
felt the calling for their church to be
a community church but still have
outreach beyond their borders to help
start other mission churches. This
vision became a reality as a small
Bible study group began in the home
of one of the members at Lay Lake,
and it has now grown into the fully
constituted Baptist Church at Lay Lake.
(Both, Riverchase Baptist Church.)

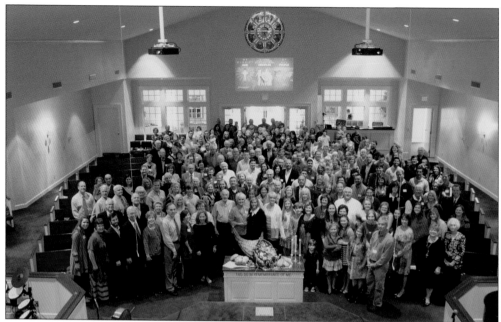

RIVERCHASE BAPTIST CHURCH'S 25TH ANNIVERSARY, 2012. The church added a contemporary worship service called 20-20 in 2010. The following year, the church added a number of small groups, including Women's Book/Bible Study, Outdoor Adventure, Marriage Enrichment, Forks and Friends, Consider the Lillies, Sports, and Men's Book/Bible Study. The church continues to support mission projects during the year. In 2012, Riverchase Baptist celebrated its 25th anniversary. Members, former members, and friends celebrated the founding of the church and, today, continue serving Christ in Riverchase and nearby communities. Pictured above in the sanctuary is the congregation at the 25th anniversary service. (Both, Riverchase Baptist Church.)

Three

BUSINESS DEVELOPMENT
THE MASTER PLAN

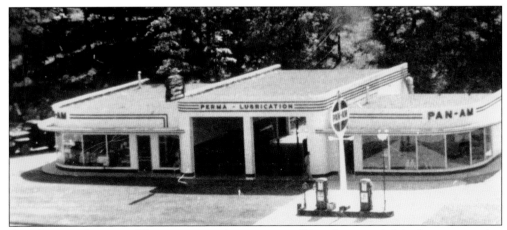

OLD SERVICE STATION. There are many businesses in Riverchase, and this chapter contains photographs and old advertisements that are sure to bring back memories. This c. 1950 photograph shows the Acton Service Station, which was the last station between Birmingham and Montgomery. (Bobby Joe Seales and Riverchase Carpet and Flooring.)

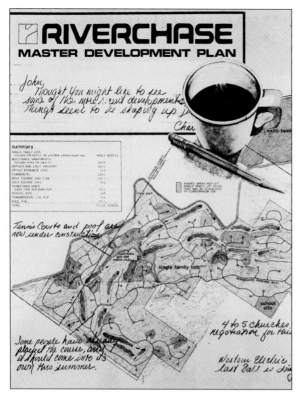

THE MASTER PLAN. This master plan foldout shows the Riverchase development in its early stages. Some things have changed, but many of the notations are sure to bring back memories. The first page shows where Riverchase Country Club is marked along with the "school site." The top of the second page notes "70 acres for a regional shopping mall"—this would become the Riverchase Galleria. Note the Jefferson and Shelby County lines and, at the bottom of the second page, a mention of the Hungry Fishman restaurant. (Both, Christ the King Lutheran Church.)

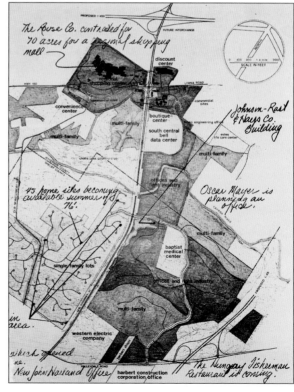

RIVERCHASE PARKWAY EAST. Pictured at right is one of the buildings on Riverchase Parkway East in early development; this is building 400 at Chace Park South nearing completion in 1981. It was built by Champion Construction Company and owned by Frank Kovach. Pictured below are the corporate headquarters of Blue Cross and Blue Shield of Alabama (founded in 1936 as Hospital Service Corporation), which are located on Riverchase Parkway East. (Right, Gerald Smith; below, author's collection.)

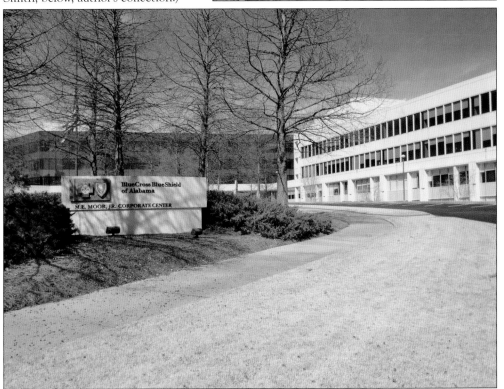

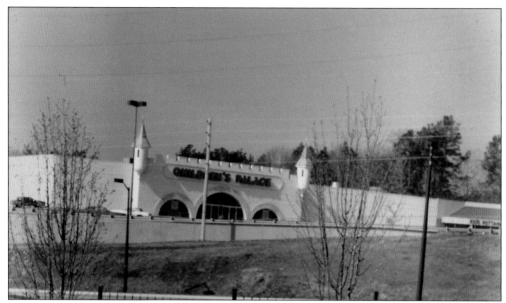

CHILDREN'S PALACE, 1990. Dating back to the 1970s, this castle-themed toy store chain was one of two anchors (the other being Circuit City) built in the Center at Riverchase in 1989. The Children's Palace brand was eventually bought by the Child World brand, and this location closed in the late 1990s. Staples now occupies the place where kids made a mad rush for Cabbage Patch Kids dolls. (Gerald Smith.)

FUDDRUCKERS ADVERTISEMENT FROM 1991. Fuddruckers, located on Galleria Circle, was a popular restaurant in the 1990s. The restaurant closed in the 2000s, and Ted's Montana Grill took over the location for a short time. Today, On Tap Sports Café occupies the location where Fuddruckers once stood. This old advertisement is from a community program. (Hoover Historical Society.)

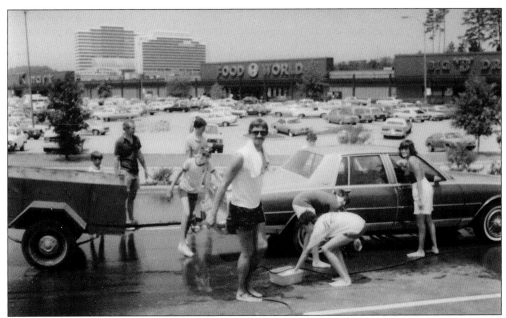

LORNA ROAD AND HIGHWAY 31. Lorna Road and Highway 31 intersect at one corner of Riverchase and offer several shopping choices. K-Mart, Food World, and Big "B" Drug Store stood on one side in the late 1980s and early 1990s. The above photograph is from a car-wash fundraiser held by Riverchase Community Church in the 1980s. Across Lorna Road, Loehmann's Village was another development in the Riverchase plan. Opened in 1979, the open-air mall was anchored by Loehmann's department store and Service Merchandise. Aronov Realty purchased the property by the 1990s, and with the last remaining anchor Service Merchandise closing in 2002, the mall was renovated. Bruno's Supermarket and two chain pet stores had been anchors of the village until Bruno's closed in 2012. Whole Foods announced in 2014 that it was moving into the Bruno's space, and construction began in 2015. (Above, Riverchase Community Church; below, City of Hoover.)

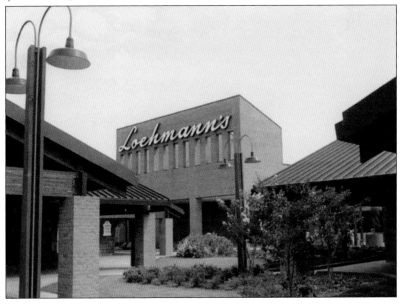

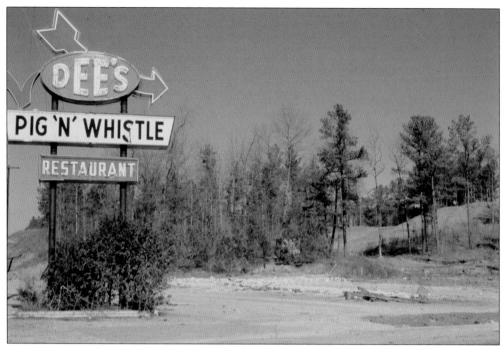

EARLY EATERIES IN RIVERCHASE. The above image shows the remains of the Dee's Pig 'N' Whistle BBQ sign. Pig 'N' Whistle was near the Cahaba River on Highway 31 (the current location of Hobby Lobby) before the Riverchase Mall (Plaza at Riverchase) was built in the late 1980s. At the time, Shelby County was dry, but Jefferson County was not. Other joints in the area included Judy's Bar, located at the Cahaba River bridge, and Murphy's Bar on Highway 150. Across the street (pictured below) is the former site of Chace Lake Country Club. The club was sold and torn down in 2008, and construction then began on Chace Lake subdivision, retail, and office space. Legacy Credit Union was the first company to purchase a commercial site in the Chace Lake area. CVS, Taziki's, and Baha Burger also opened in the development. (Above, Capt. W.P. Gresham (ret.), Hoover Fire Department; below, author's collection.)

GOOD FOOD AND MEMORIES. Pictured at right in the late 1980s are employees of the Hungry Fishman restaurant that was once located in Riverchase. In the red sweater is Tammy Jones, in the blue shirt is Neal Carter, and the woman in blue at far right is Janet Griffin. All that is left of the Fishman restaurant is a billboard (below) on which the logo, although faded by time, is still visible. (Right, Stephanie Collins; below, Scott Ford Photography.)

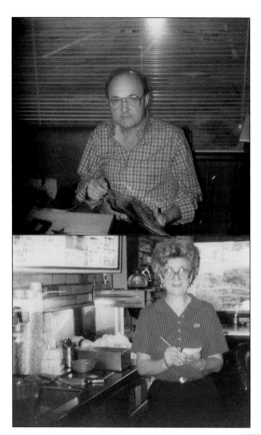

TIME FOR SOME BARBECUE. Joe and Fannie Lovoy, pictured at left, were well known for their barbecue and opened a family restaurant in Riverchase in the 1970s. The Double LL Bar-B-Q restaurant was located near the Hungry Fishman building and had an open pit where customers could see the meat cooking. The restaurant also served ribs, seafood, steaks, and hamburgers, among other favorites and specialties. (Both, Lisa Ann Lovoy.)

At Riverchase Inn a good night is a good buy.

RIVERCHASE INN. Prior to being called the Riverchase Inn, one of the first hotels in the Riverchase area went by the name The Cricket Inn. The Cricket Inn opened on Highway 150 in 1988. Archive files on the property show that much of the land around it was used for mining. The 1940 photograph below shows a coal hopper/washer that once sat on this property. Today, the Riverchase Inn is now a Days Inn but is still standing in the same location. (Above, Hoover Historical Society; below, Birmingham Public Library Archives.)

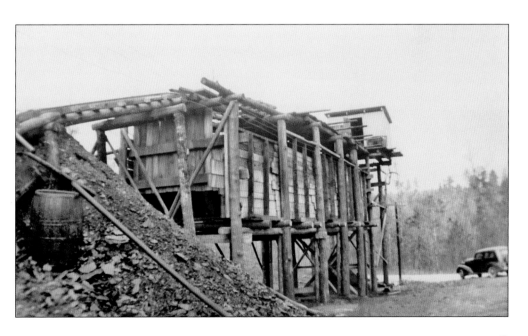

GALLERIA FIRE. On June 5, 1985, the Riverchase Galleria was close to completion when a fire broke out that made headlines in the local news. The fire occurred on the roof of the mall's office tower, causing extensive damage to the roof and the top floors of the tower. Gerald Smith, building official and director of inspection service during that time, remembers it well. "I was at my office at the old city hall when we received notice that the Galleria was on fire." It was quite a scene, as thick, black smoke plumes could be seen for miles. The above view from the front was taken from the Hoover inspector's remote office, which was on-site. The below photograph was taken from Highway 31. (Both, Gerald Smith.)

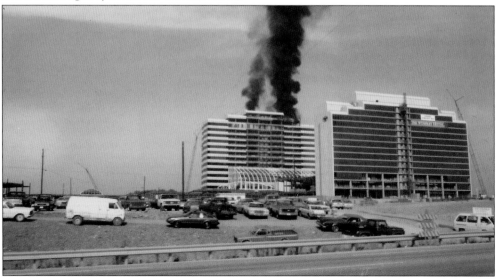

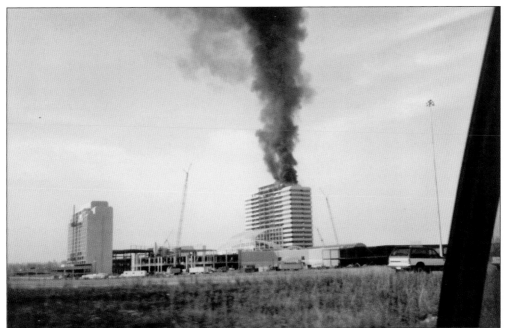

SMOKE RISES. Standpipes, which are for fire protection, were in place when the Riverchase Galleria building was being erected. The fire was essentially caused by the hot tar roofing kettle shown below; note the two unidentified men in the background with hose pipes. In 2003, Jim Wilson & Associates sold 50 percent of the Galleria to General Growth Properties, which assumed management control. Patton Creek, behind the Galleria, was built in 2003, and new anchor store Von Maur opened in 2013. (Both, Gerald Smith.)

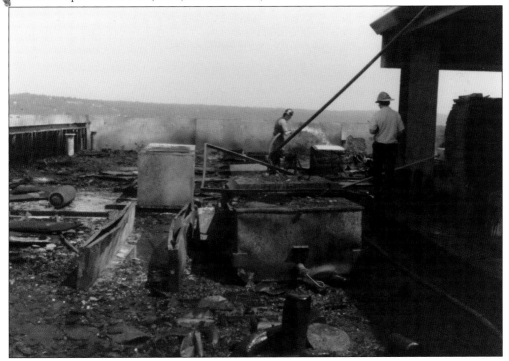

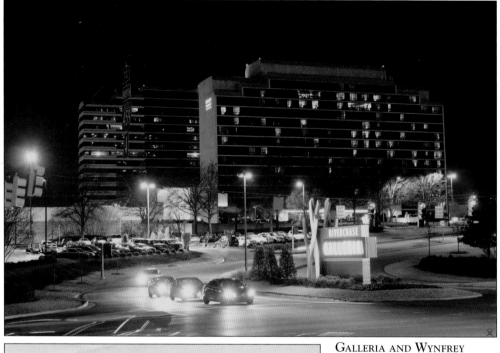

THE WYNFREY NEWS

Pre-opening Sales Office
2084 Valleydale Road
Birmingham, Alabama 35244
205/987-1600

VOLUME 1 NUMBER 3 THE WYNFREY HOTEL AT RIVERCHASE GALLERIA FALL 1985

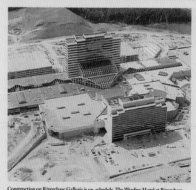

Construction on Riverchase Galleria is on schedule. The Wynfrey Hotel at Riverchase Galleria, front, will have a soft opening January 6, 1986, while the remainder of the Galleria, including the Galleria Office Tower, rear, will open February 19, 1986.

Convention Space At Wynfrey Unmatched

The Wynfrey Hotel at Riverchase Galleria will be bringing convention space to the state meeting market which is "unmatched in quality and size," said hotel General Manager J. Rudi Heater.

When the hotel opens in February, approximately 25,000 square feet of space in the 15-story hotel will be designated for conventions and meetings, Heater said. "The Wynfrey Hotel at Riverchase Galleria will have more meeting and convention space than any other hotel in the state.

"But we didn't stop there in bringing unique qualities to this 330-room luxury hotel," Heater said.

Special amenities in the hotel, part of the $300 million Riverchase Galleria, include private meeting planners' offices, a custom-designed convention registration area and a "mammoth freight elevator."

Continued on Page 4

Construction on Schedule for Wynfrey at Riverchase Galleria

Construction on the Wynfrey Hotel at Riverchase Galleria is "progressing well," according to J. D. "Buddy" McClinton, Executive Vice President for Development for Jim Wilson and Associates, developers of the Galleria.

Drywall work is being completed in the lobby area and convention level, McClinton said. "The hotel is really taking shape and beginning to look like a luxury hospitality facility."

The hotel's escalators which will move guests from the lobby to the second-floor convention level are installed and elevators are also being readied, McClinton added.

Work in the Tower, which houses the 330 guest rooms of the hotel, is on schedule, McClinton said. Wallpaper installation in

the rooms is nearly completed and marble vanities in place, he said.

Carpet and furniture will be installed just before the soft opening of the hotel, set for January 6, 1986. Approximately 100 rooms, as well as one restaurant and lounge, will open then, a month before the Grand Opening ceremonies scheduled for February 19.

"The view from each room of the Wynfrey Hotel at Riverchase Galleria is spectacular," McClinton said. Each room has a full-size wall window overlooking wooded hills and valleys or the mall area itself.

"This project is right on schedule," McClinton said. "Every time I tour the site I am amazed at the progress. It's exciting to watch this hotel come to life."

Briggs

Briggs Named Marketing Director at Wynfrey at Riverchase

Walter E. (Bud) Briggs has joined the Wynfrey Hotel at Riverchase Galleria as Director of Marketing, according to Wynfrey Hotels, Inc. President Dan Gifford.

Briggs is responsible for all sales, marketing, advertising and public relations for the 330-room luxury hotel, Gifford said, which is scheduled to open in February.

"Briggs' comprehensive hotel sales and marketing experience is a plus in positioning

Continued on Page 4

GALLERIA AND WYNFREY HOTEL.

Pictured at left is volume 1, issue 3 of the *Wynfrey News*. The Wynfrey Hotel at Riverchase Galleria added high style—along with needed convention space—with its approximately 25,000 square feet, 330 luxury rooms, and two restaurants. The hotel's soft opening was held in January 1986. It stands 15 stories tall and was designed for conventions and meetings. The original Winston's restaurant was replaced by Shula's, owned by former NFL coach Don Shula, in 2003, and in early 2012, after millions of dollars of renovations, the hotel was rebranded as Hyatt Regency Birmingham–The Wynfrey Hotel. For at least 10 years, one of Wynfrey's permanent residents has been a black and white cat named Wynfrey. (Above, Robin Schultz; left, Gerald Smith.)

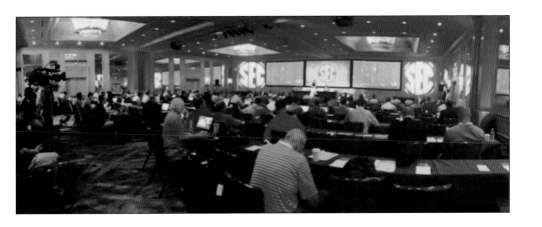

SEC IN RIVERCHASE. Dating back to 1988, the Wynfrey has a long-standing tradition of being the host hotel for the Southeastern Conference's annual SEC Media Days. This event brings in hundreds of journalists, radio stations, university and conference officials, and SEC players and coaches. The above photograph is from day one of the 2015 SEC Media Days. University of South Carolina head football coach Steve Spurrier is at the podium in the below image. Many coaches spoke at the 2015 event, including University of Alabama head football coach Nick Saban, who headlined day three. (Both, Scott Forester.)

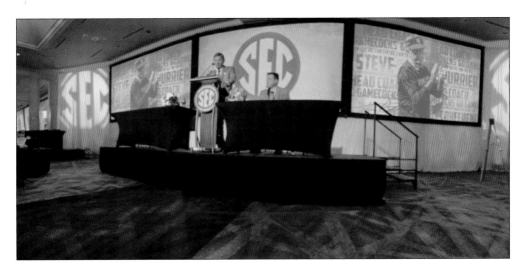

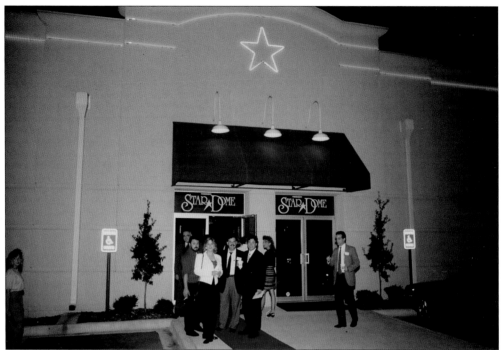

Funny Times. Since 1983, Bruce and CheChe Ayers (pictured below) have brought laughter to crowds with live comedy performances at their family business, the Comedy Club StarDome. In the club's early years, then-unknown talents like Tim Allen, Sinbad, Steve Harvey, and James Gregory performed on the stage of the Comedy Club's first location in Homewood. The above photograph was taken in 1993 on the opening night of the StarDome's new location on Data Drive in Riverchase, where it still hosts delighted crowds. Comedy excellence continues at the StarDome, with appearances by comics such as Jeff Dunham, Killer Beaz, Rickey Smiley, and Tom Arnold, to name a few. For more than 30 years, the StarDome has seen many acts come through its doors, and the Ayerses have helped many establish their careers with a jump-start from Alabama. (Both, Bruce Ayers.)

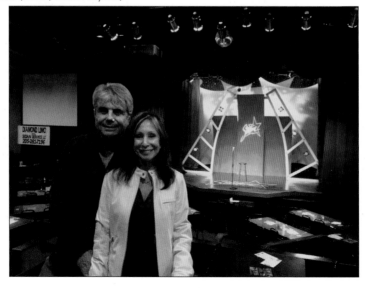

Four

RIVERCHASE
A PEOPLE

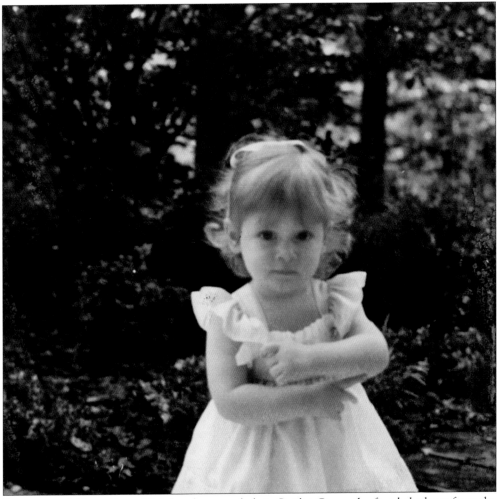

RIVERCHASE'S FIRST BABY. This lovely young lady is Caitlin Carey, the first baby born from the original group of residents who called themselves the Riverchase Pioneers. Caitlin is a true native of Riverchase and is shown here at the annual neighborhood picnic at Wildflower Park in 1978. (Carey family.)

Notes taken Friday, October 19, 1984

Meeting called to order and conducted by Ruth O'Barr. The purpose was to discuss the possibility of starting a sociable garden club in Riverchase. Those attending paid $2.50 for coffee and sweet rolls. Nineteen (19) Riverchase women attended.

Jackie Barker

Phyllis Burnett

Cynthia Cotton

Beverly Dobbins

Allene Dunnam

Alice Everage

Mary Headley

Charlotte Heald

Ann Jones

Dollie Kerr

Nancy Lawlor

Doris MacMurray

Ruth O'Barr

Sue Reeder

Inez Ware

Carol Warren

Gerry Wiggins

Wendy Wells

Shirley Woodruff

Ruth O'Barr introduced our guest speaker, Mr. Jim Garner of Heritage Nursery (822-3172) who spoke on Problems & Solutions of Gardening in Birmingham. His presentation was excellent and well received, with many questions following.

A business meeting followed with open discussions from the floor. Many excellent suggestions were made for getting organized. During the discussion Charlotte Heald was asked to act as chairman since Ruth O'Barr felt she had enough to do.

A vote was taken to consider either a coffee or a brunch. The majority voted for a brunch. A suggestion was made to exchange $5.00 gifts at the December meeting.

The suggestion was made to hold the next two meetings on the second Friday of the month during November and

RIVERCHASE GARDEN CLUB BEGINNINGS, 1984. In 1984, Ruth O'Barr hosted a planning meeting at her home to discuss with other Riverchase residents the possibility of starting a garden club in Riverchase. On October 19 that year, a coffee meeting held at Riverchase Country Club included 19 Riverchase women who attended to discuss the idea. At left is a page from the club's scrapbook noting the day's events. Guest speaker Jim Garner of Heritage Nursery spoke on problems and solutions for gardening in Birmingham, followed with a discussion of suggestions for getting the club organized. Over the month, the fledgling club established bylaws, installed officers, and outlined its purpose. Some of the first officers pictured below (in no particular order) at the club's first Christmas Brunch in 1984 are Allene Dunnam, president; Sue Reeder, secretary; and Ruth O'Barr, parliamentarian. (Both, Riverchase Women's Club.)

FASHION SHOW. The garden club hosted more events, activities, and missions throughout 1984. Modeling the 1980s style is club member Sue Doleys in a green ensemble with hat at the first fashion show held at the country club. Member Kay Ray is looking on in the background. (Riverchase Women's Club.)

DOGWOOD TRAIL, 1985. The garden club also participates in the annual Dogwood Trail and Decorations Show House. Members Becky Edwards (left) and Sarah Ellen Gaissert (right) are pictured at the 10th Annual Hoover Dogwood Trail, presented by the Birmingham Board of Realtors and Hoover Beautification Board. Two homes in Riverchase were featured on the tour in 1985, and the garden club was a sponsor. (Riverchase Women's Club.)

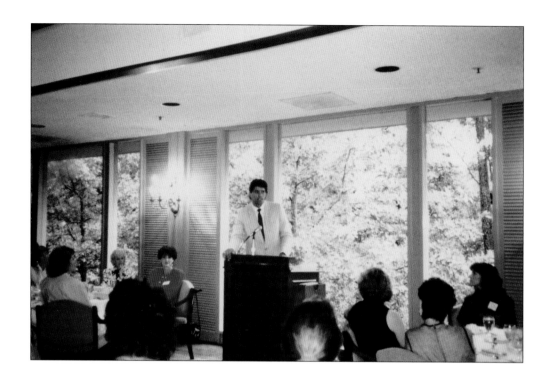

A Growing Community and Club. As Riverchase grew, so did the garden club. In 1987, the club changed its name—to the Riverchase Women's Club—and its focus. The club's members put a large focus on serving their community and local charities while still working to stimulate appreciation for the beauty of homes and gardens and promote a closer neighborhood atmosphere. The club also hosted an annual charity auction. John Croyle, founder of Big Oak Ranch, is pictured above at the 1987 auction. In 1989, "Holly Fest" was the theme of the club's Christmas dinner dance and fashion show benefiting Magic Moments. Big Oak Ranch and Magic Moments are two of the many charities that the club has raised money to support. (Both, Riverchase Women's Club.)

RIVERCHASE WOMEN'S CLUB IN THE NEW MILLENNIUM. Pictured above at a Riverchase Women's Club luncheon are, from left to right, Karen Norris, Elizabeth Smith, and two unidentified women. The 2000s saw new adventures for the Riverchase Women's Club and new opportunities to continue the great work the club does for charities. Members of the Riverchase Women's Club are pictured below in 2003. (Both, Riverchase Women's Club.)

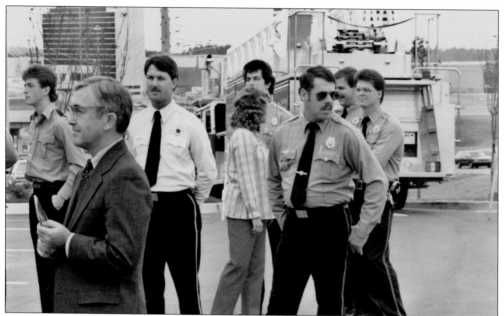

Protective Services. Prior to annexation into the city of Hoover, Riverchase had a volunteer fire department and was covered by Shelby County police. When Hoover annexed Riverchase in 1980, the fire department merged with Hoover's, and three additional officers were hired for the growing Hoover Police Department: James Coker, Stan Porter, and Jeff Key. At the time, the Hoover Police Department had only three beats. (Hoover Police Department.)

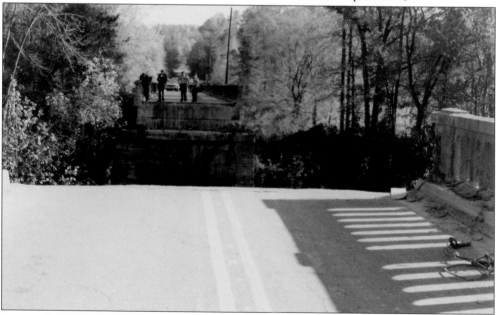

Bridge Out, 1980s. Pictured here is old Highway 31 (then called Lower Lorna Road) as officers inspect the bridge after it collapsed. The bridge was hit by a truck, and both the bridge and the truck fell into the Cahaba River. This caused major traffic problems, because the bridge was one of only two ways into Riverchase at the time. Following repairs, traffic flow returned to normal. (Hoover Police Department.)

FIRST BADGE. This is one of the original captain's badges from the Riverchase Volunteer Fire Department. The volunteer fire department was active from 1977 until the Riverchase Fire District and its employees were annexed into the city of Hoover in 1980. The annexation of the district made a great impact on the Hoover Fire Department, as eight additional men were hired to serve Riverchase. (Carey family.)

FIRE STATION NO. 3, 1995. The original Riverchase Volunteer Fire Station was near the old Cahaba River bridge. After annexation, the station moved across the street to a vacant office. In December 1981, Fire Station No. 3 was built at 803 Riverchase Parkway West. This 1995 photograph shows the old Mack pumper, one of Hoover's first engines, parked outside of Station No. 3. (W.P. Gresham.)

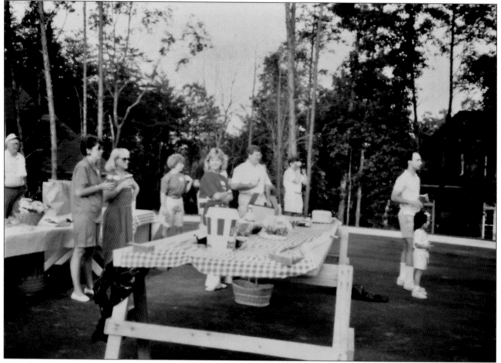

FAIRWAY BLOCK PARTY. These Riverchase residents are enjoying a block party on Fairway Court in May 1989 with a picnic tables, food, and games. Identified in the above photograph are Barbara Hatmaker (in turquoise), Heyward Menasco (holding a blue cup), and Bob Osborn (holding a camera). The Hoover Fire Department brought the old Mack pumper out for the event as well. Wayne Kelley is at far right in the below photograph. (Both, Karen Walker.)

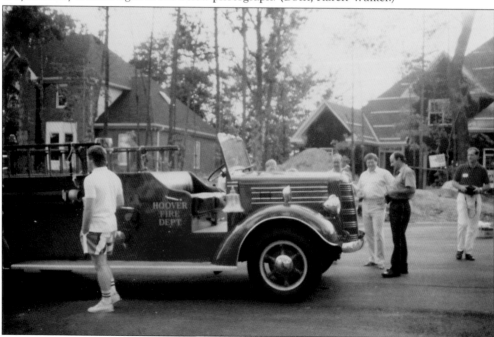

THE HOOVER BELLES. The Hoover Belles, hostesses for the city of Hoover, were established in 1980 by Faye Anderson and are still an active part of the city. Shown at a 1996 event are two Hoover Belles with their mothers. From left to right are Merritt Musso; Merritt's daughter, Laura Musso; Meghan Carey; and Meghan's mom, Linda Carey. The Careys are Riverchase residents. (Carey family.)

ART SHOW. Riverchase Loves Artists sprang from the mind of Riverchase Women's Club president Lynne Cooper in 2006. These art shows are held at Riverchase Country Club, and the club is the driving force behind them. Held around the first week in February, the show benefits different charities each year. In its first year, the show benefited Alzheimer's of Central Alabama, the Amelia Center, and the Exceptional Foundation. (Riverchase Women's Club.)

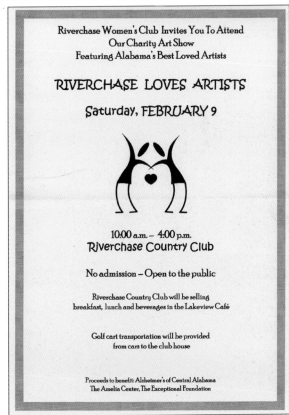

Riverchase Women's Club Invites You To Attend
Our Charity Art Show
Featuring Alabama's Best Loved Artists

RIVERCHASE LOVES ARTISTS

Saturday, FEBRUARY 9

10:00 a.m. – 4:00 p.m.
Riverchase Country Club

No admission – Open to the public

Riverchase Country Club will be selling
breakfast, lunch and beverages in the Lakeview Café

Golf cart transportation will be provided
from cars to the club house

Proceeds to benefit: Alzheimer's of Central Alabama
The Amelia Center, The Exceptional Foundation

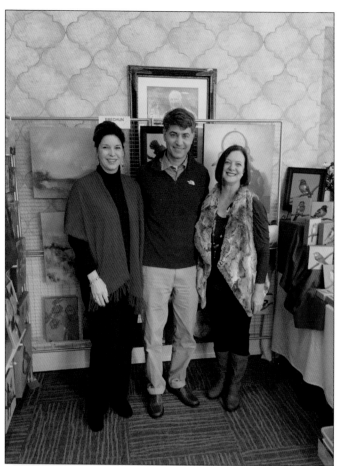

ENJOYING THE ART SHOW. Pictured at left at the 2015 Riverchase Loves Artists are Lori Schommer (left), Paul DeMarco (center), and Linda Joseph. The show has evolved over the years, but love for the artists and the community has always been at the heart of the show. The mixture of artists means that there is something for everyone—from jewelry, pottery, and paintings to furniture, glass, and textiles. Riverchase Loves Artists attracts many local and national artists from amazingly diverse disciplines. (Left, Linda Joseph and Paul DeMarco; below, Riverchase Women's Club.)

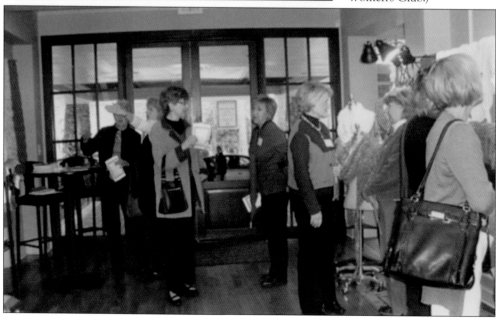

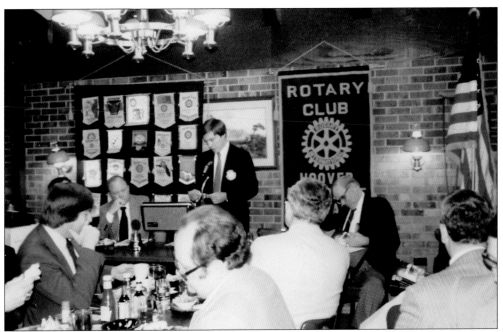

"SERVICE ABOVE SELF." So reads the motto of the Hoover-Riverchase Rotary Club. The club was chartered in October 1977 with 25 members, including C. Lee Nelson, Stan Susina, Robert Richardson, and Ted Schneider. Member Larry Sparks is pictured above at the podium bringing a Rotary Club meeting to order in 1984. To Larry's left is the late Dan Burton of Burton Construction Company. In the early 1990s, the club changed its name to Hoover Rotary Club to include all areas of the city. Pictured below at a meeting in 2015 are, from left to right, members Rex Webb, Andy Peters, Lindy Davis, Terry Turner, Matthew Allen, and Jay Lutenbacher. (Above, Larry Sparks; below, Matthew Allen, Hoover Rotary Club.)

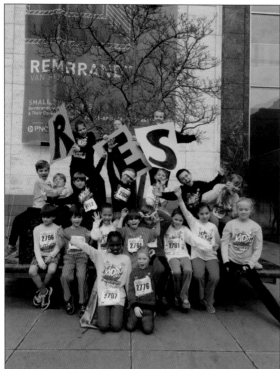

MERCEDES KIDS. Since 2002, Mercedes Marathon has been an annual February event in Birmingham. Marathon weekend also includes the Mercedes Kids Marathon. Pictured here are Riverchase kids who ran in the 2015 Kids Marathon. The primary sponsor, German automaker Mercedes-Benz, has a plant in Tuscaloosa, Alabama. The proceeds from the marathon go to local charities including Children's Hospital, the Bell Center, and Kid One Transport. (Martha Storm.)

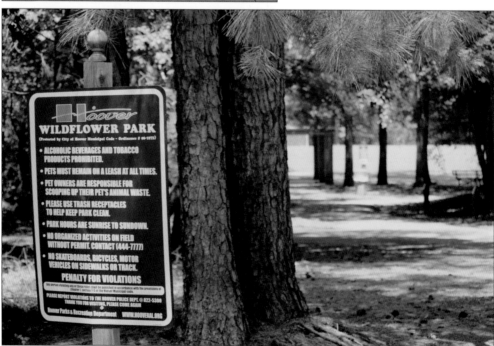

HOOVER PARKS IN RIVERCHASE. Hoover has several parks throughout the city for residents to enjoy. Two parks are located in Riverchase and are much loved by the community. Wildflower Park is located just off Riverchase Parkway at the end of Wildflower Road, and Chace Lake Park is located in the Chace Lake subdivision off Highway 31. (Hoover Park and Recreation.)

NATURE IN THE BACKYARD. All the streets leading off of Riverchase Parkway and Lake Forest Circle are nature-themed, featuring names like Oak Tree, Flowerwood, Tulip Poplar, Whip-poor-will, and Partridge Berry. Wildflower Park is great for walking, pets, and picnics and has a playground for kids. Pictured below are some Riverchase kids hiking in the woods of Wildflower Park. From left to right are Andrew and Sophia Hulcher, Tyler Young, Andrew Moses, and Sameer Hajiani. (Above, Hoover Parks and Recreation; below, Angela Hulcher.)

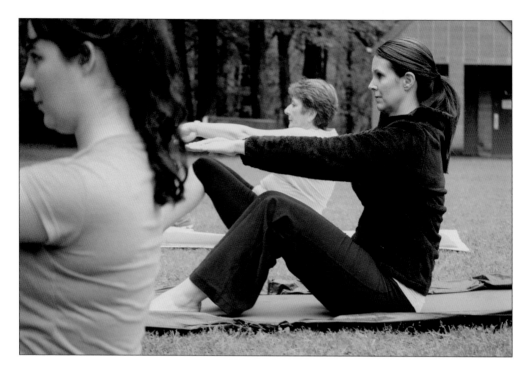

PILATES IN THE PARK, 2015. On a pretty April day, it is common to see a Pilates class or two at Wildflower Park. Pictured below stretching and enjoying the class are Jamie Foster (in black), Jason VonBehren (in gray), Cath Young (in orange), and Hanna Rae Joseph (in blue). (Both, Hoover Park and Recreation.)

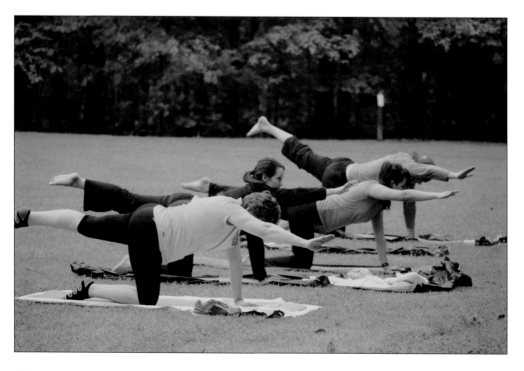

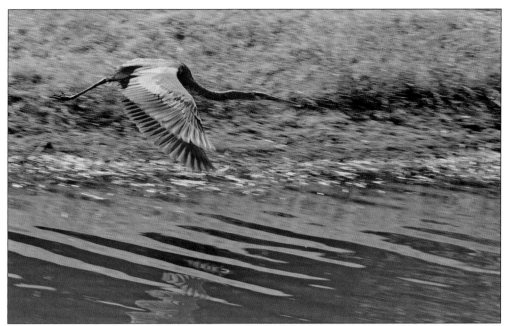

CHACE LAKE. Above, a great blue heron flies over Chace Lake, where residents enjoy the lakeside view. The community sits on land once home to the member-owned Chace Lake Country Club. The club opened in 1962—before Hoover was even a city—and closed in 2008. The property was sold to Signature Homes for the development of the 123-acre Chace Lake community. The plan called for over 200 homes and around 40 acres of public park and green space on the river. Retail and office spaces were set to close to Highway 31, with the community behind them. Construction began on the Chace Lake community in 2008. Chace Lake Park contains a nine-acre lake, pavilion, and walking track and trails. (Both, Paul "Oak" Aucoin.)

SNOWSTORM OF THE CENTURY. The 1993 blizzard dumped 17 inches of snow in the Birmingham area, with six-foot drifts, according to the National Weather Service. This "once-in-a-lifetime event" left more than 46,000 northern and eastern residents without power and stranded for several days in March 1993. All 67 counties in Alabama saw snow. Snow in Alabama is not a common occurrence, so the blizzard of 1993 was one of the top stories of the year. Pictured below keeping warm during the 1993 snow are Jan Fry (left), Beth Marsh (center), and Konie Bryant Clark. (Above, Riverchase Women's Club; below, Spencer Rogers.)

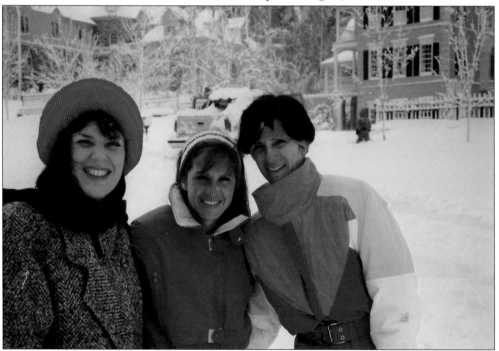

SNOW AGAIN. Birmingham's rare 1993 snowstorm had a 2014 sequel. January 28, 2014, started like any ordinary winter day in central Alabama. The forecast called for a light dusting of snow, but two inches of snow fell, and temperatures dropped into the teens by noon. The day is remembered as "Snowpocalypse 2014," a day the majority of the Birmingham area, including Riverchase, froze solid. Stranded motorists had to sleep in their cars overnight until warmer temperatures the following day melted the snow. Some motorists walked miles to get home or to reach someplace warm. The unexpected snowstorm not only caused travel problems on interstates and highways, it also caused travel problems in residential areas. Vehicles slid all over the road, with some sliding into each other on sheets of ice. (Right, Martha Storm; below, Heather Morin.)

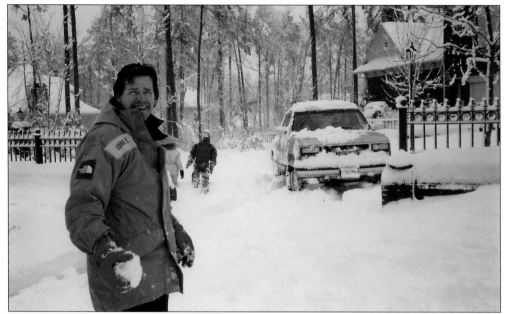

DR. BILL BRYANT (1953–2006). For over 23 years, Riverchase resident and gifted orthopedic surgeon Dr. Bill Bryant practiced medicine in the Birmingham/Hoover area, loving what he did and the people he treated. Bryant also served as the team physician for Hoover High School athletics. Dr. Bryant is pictured here at the family's Riverchase home during the March 1993 snowstorm. Dr. Bryant passed away in 2006 and is survived by his wife, Konie, and their children, Justin, Jessica, Jarod, and Jenna. (Spencer Rogers.)

BART STARR. Longtime resident and football pro Bart Starr lives in Riverchase with his wife, Cherry, and their family. Starr played college football for the University of Alabama and was drafted as a quarterback for the Green Bay Packers. Starr played from 1956 to 1971 and coached the Packers from 1975 to 1983. Among his many honors and awards, Starr has been inducted into the Pro Football Hall of Fame and the Alabama Sports Hall of Fame. (Amy Luther.)

Five

RIVERCHASE
COUNTRY CLUB
THE CORNERSTONE

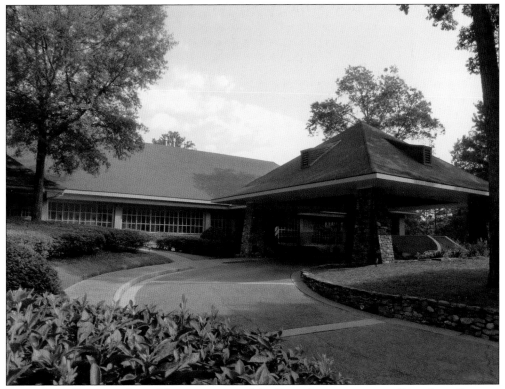

RIVERCHASE COUNTRY CLUB. The centerpiece of the Riverchase community, Riverchase Country Club, was built in 1976. Today, the club functions as a full-service, member-owned facility with many amenities and activities. The course measures 6,842 yards and features Bermuda fairways and bent grass greens. (Riverchase Country Club.)

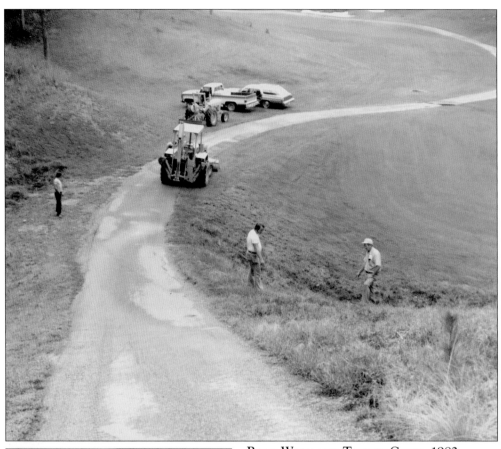

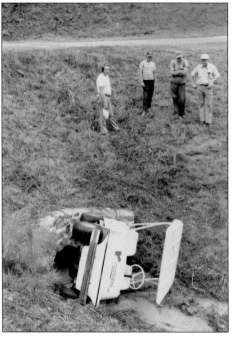

ROAD WORK AND TOPPLED CARTS, 1982.
These are two early photographs of the golf course during some construction and maintenance work. On this particular day, there was also a small accident that involved a golf cart rolling down one of the hills. (Both, Riverchase Country Club.)

PAR FOR THE COURSE. Riverchase Country Club features an 18-hole, Joe Lee–designed golf course, 15 tennis courts, a Junior Olympic–sized swimming pool, a state-of-the-art fitness center, and dining opportunities featuring both fine and casual offerings. The club also offers facilities that can accommodate events ranging in size from small gatherings to large, elaborate wedding receptions. (Both, Riverchase Country Club.)

THE DESIGN. The Joe Lee–designed golf course opened for play in 1976. The first player to tee off on Riverchase's course was professional golfer Gene Sarazen, one of only five golfers to win all current major championships during his career. Each year, the Easter Bunny visits the club for an Easter egg hunt and lunch. (Both, Riverchase Country Club.)

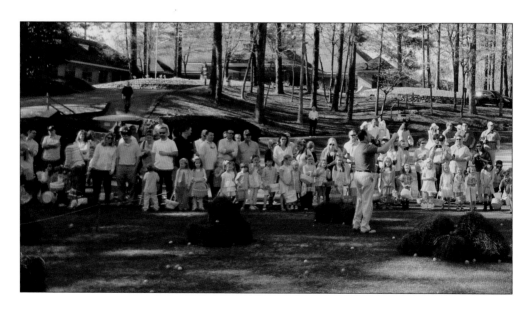

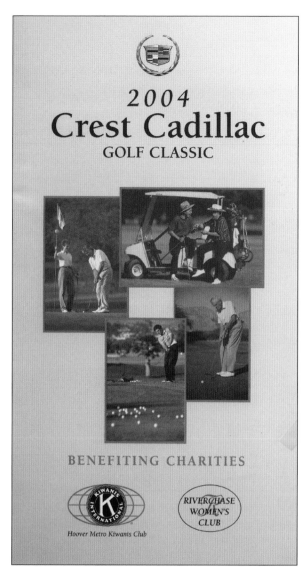

2004
Crest Cadillac
GOLF CLASSIC

BENEFITING CHARITIES

Hoover Metro Kiwanis Club

RIVERCHASE WOMEN'S CLUB

GOLF TOURNAMENTS. Several tournaments are held at Riverchase Country Club each year. At right is a pamphlet from the 2004 Crest Cadillac Golf Classic, sponsored by the Hoover Metro Kiwanis Club and the Riverchase Women's Club. Pictured below are carts and golfers ready to hit the links at the event. (Both, Riverchase Women's Club.)

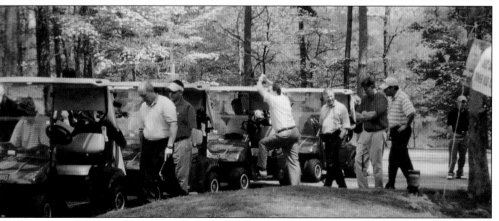

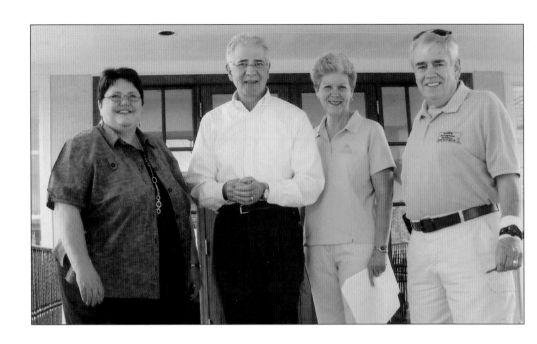

THE 2004 CREST CLASSIC. Pictured above at the 2004 Crest Cadillac Golf Classic are, from left to right, Kathy Wells, Hoover mayor Gary Ivey, Sylvia Sumners, and Dave Broderick. Below, golfers enjoy the day. (Both, Riverchase Women's Club.)

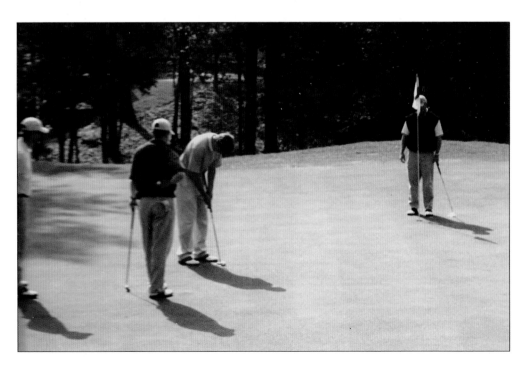

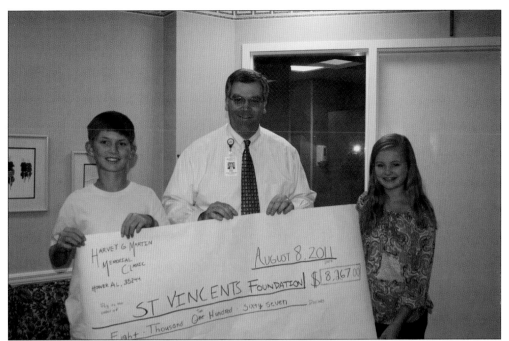

MEMORIAL FOR HIS GRANDFATHER. Harvey Martin loved the game of golf. He often played with his friends, "The Wolf Pac," at Riverchase Country Club. In 2009, Martin fought the good fight battling prostate cancer before passing away in November. In 2010, as a memorial in his grandfather's honor, Harvey's grandson Patrick started a tournament for youth ages 8 to 18. All donations go directly to the St. Vincent's Foundation, where Harvey received treatment. In 2015, the tournament was opened to all ages. Above, presenting the donation check during the 2011 tournament are Patrick Martin (left), Scott Powell (center), and Lilly Martin. Pictured below playing in the Harvey G. Martin Memorial Classic are, from left to right, Jackson Seawell, Patrick Martin, William Walker, Crawford Flach, Banks Nash, and Beau Scott. (Both, Christine Martin.)

MARTIN FAMILY. Pictured on the green at the Harvey G. Martin Memorial Classic are, from left to right, (first row) Olivia Stark, Hadley Hayes, Lilly Martin, Ian Stark, Christopher Martin, Matthew Stark, Casey Martin, and Catherine Stark; (second row) Christine Martin, Leslie Smith, Charlie Hayes, Patrick Martin, and Connor Hayes; (third row) Kerrie Hayes, Greg Martin, Amy Stark, Vic Stark, Lynwood Smith, Phil Hayes, Jan Martin, Brandy Martin, Steve Martin, Katie Martin Beckum, and Will Beckum. (Christine Martin.)

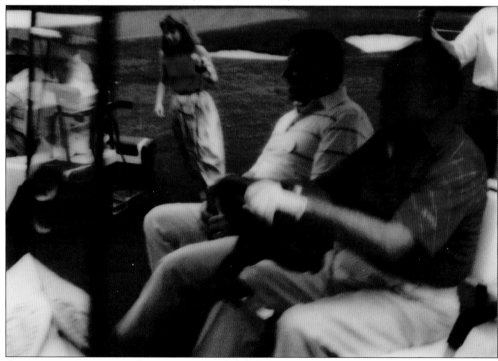

CELEBRITY HOST. Riverchase Country Club has been fortunate to host many local leaders, professionals from the world of golf, and national celebrities. Michael Jordan has been spotted at Riverchase, and even presidents such as Gerald Ford have played here. Bob Hope and Charlie Boswell frequented the club and tournaments. The legendary Bob Hope is pictured here driving in a golf cart at Riverchase Country Club in the 1980s. (Peggy Roberts.)

ANYONE FOR TENNIS? Since its opening in 1976, Riverchase Country Club has been known for having one of the premier tennis programs in the area. Both men and women compete in league tennis, and junior programs are available for all ages and skill levels. Teams for both men and women participate in US Tennis Association (USTA) league tennis from the 2.5 level to the 4.5 level. Riverchase Country Club hosts numerous USTA-sanctioned tournaments for both adults and juniors. Pictured above are some female competitors in the 1980s and, at right, Maureen King and Rick Reagan are shown playing at the Riverchase Country Club ProAm. In addition to playing in tournaments, members are involved in numerous social and competitive tennis events, such as the popular Taco Tennis, the annual ProAm, and the Club Championships. (Both, Pam Roberts.)

SOCIAL COUNTRY CLUB. The Riverchase Country Club hosts many social events for members throughout each season. These two photographs from the late 1980s show gatherings at the pool and members having fun eating and socializing. (Both, Riverchase Country Club.)

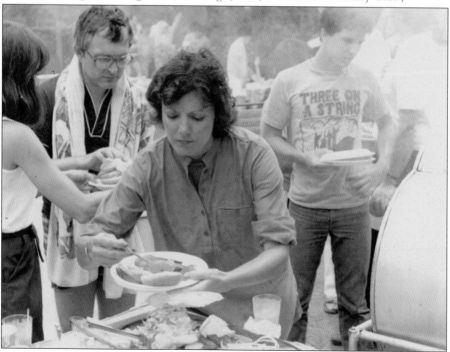

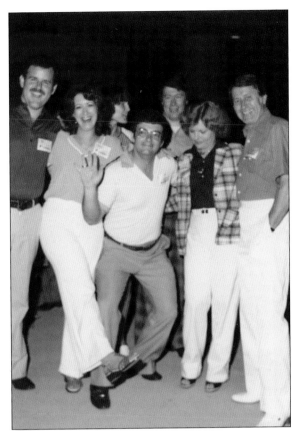

GOOD TIMES AND LADIES' TEE TIME.
Pictured at right in the late 1980s are
members enjoying an evening at the
Riverchase Country Club. Below, a
group of unidentified ladies pose for
a quick picture by the golf cart before
heading out for a day on the links.
(Both, Riverchase Country Club.)

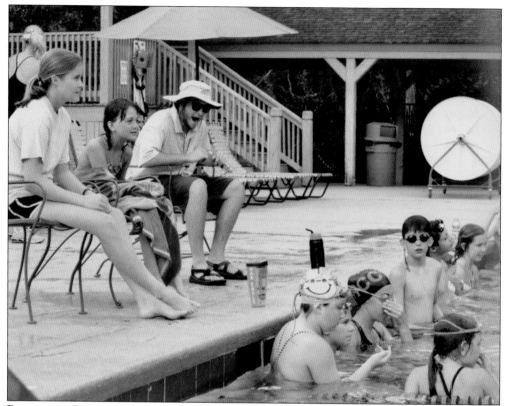

BUTTERFLY, BACKSTROKE, SWIM! The swim team has been an integral part of the Riverchase Country Club and the Riverchase community since it was founded in 1977, bringing together a wide range of families for a fun summer season. Today, the team averages around 70 swimmers from ages four to 18. Although the swim team is designed as a fun summer activity for members' families, the team is very competitive. In 2015, one of Riverchase's swimmers, Mary Caroline Hatch, broke the six-and-under girls' backstroke record for the Greater Birmingham area. Pictured above sitting next to the pool are, from left to right, coach Madison Luther, Hatch, and coach Wes Holley. (Above, Amy Poirier; below, Amy Luther.)

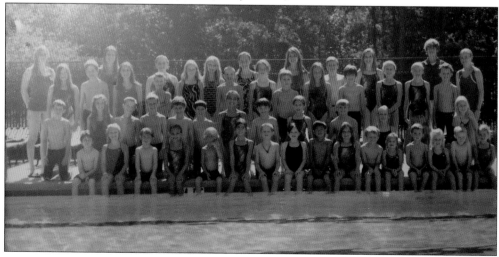

Six

HOLIDAYS IN RIVERCHASE
BRING ON THE FUN

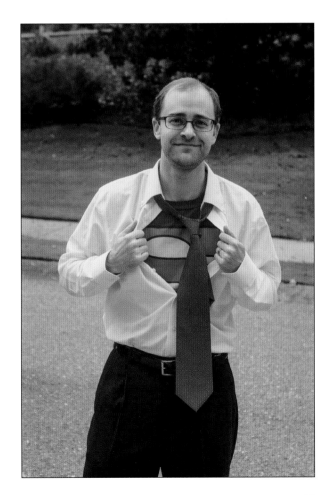

RIVERCHASE SUPERMAN, 2015.
When it comes to holidays in
Riverchase, the community goes
all out! From celebratory events
at Riverchase Country Club to
neighborhood trick-or-treating,
holidays always provide for
some great photo opportunities.
Pictured here on Halloween
night is Chris Whatley dressed
as mild-mannered reporter Clark
Kent—aka Superman. (Teth Lee.)

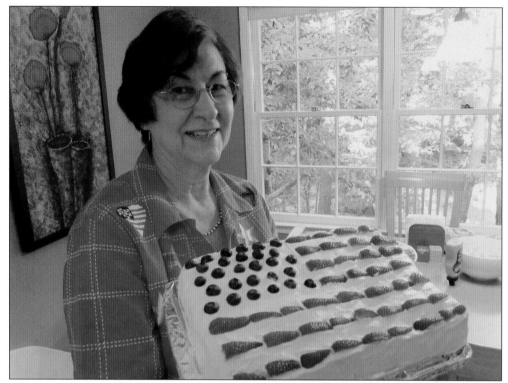

RIVERCHASE CAKE LADY. Each year, Riverchase Country Club celebrates the Fourth of July with the Riverchase community. Pictured here at the 2012 celebration is Cindy Adams holding a scrumptious flag cake adorned with strawberries, blueberries, and whipped cream (Heather Morin.)

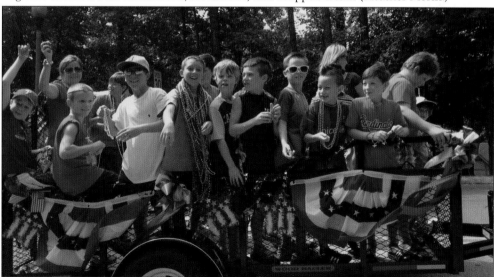

RIVERCHASE KIDS ON THE FOURTH OF JULY. Riverchase kids are always the life of the party! Shown here on the kids' float during the 2014 neighborhood parade are, from left to right, Quinn Trower, Amy Poirier, Alex Cotumaccio, Christopher Gaylor, Dylan Fraser, William Vinson, Logan Edwards, Connor Stout, Charlie Trower, Jake Swafford, and Griffin Poirier. The celebrations concluded with a fireworks display at Riverchase Country Club. (Amy Poirier.)

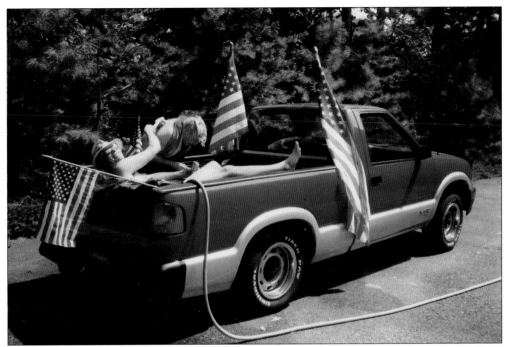

FUNNY FOURTH, 1990. It can get hot during the summers in Riverchase, but these residents found a great way to cool off! Pictured above are Bob Osborn (in the bed of the truck) and C.H. Walker having some fun after a morning doing yard work prior to the annual July 4 celebration. Osborn filled the bed of the truck with water, and his wife, Linda, drove him and Walker around the neighborhood while they waved to passersby and brought smiles to everyone's faces. (Both, Karen Walker.)

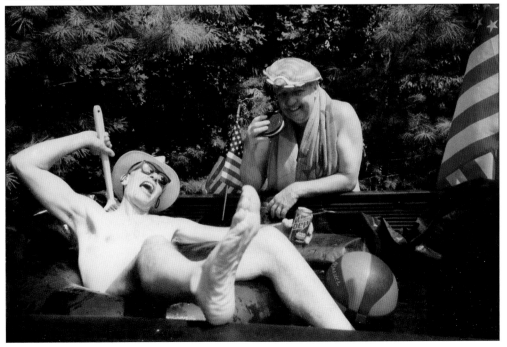

DOOR DECOR AND COSTUMES GALORE. October brings Halloween, and in Riverchase, this is always a big event for the members of the community. From decked-out doors like Stephanie Lansden's (pictured at left) to the local church fall festivals, Riverchase gets its creative juices flowing each Halloween season. There is even a pumpkin-carving event at the country club. Pictured below in 2015 at Riverchase United Methodist Church's Trunk or Treat is Hoyt Cleckler dressed as a mouse in his mousetrap mobile. Watch out for cats! (Left, Stephanie Lansden; below, Riverchase United Methodist Church.)

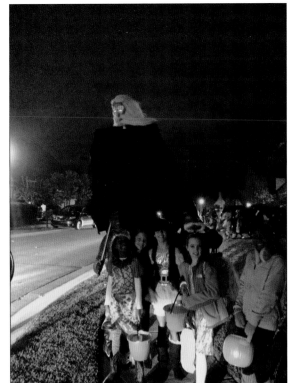

SPOOKY EYES AND HAYRIDES. Arbor Hills, a section of Riverchase, is great for trick or treating, as residents load into a hayride and go from house to house. In 2014, Riverchase resident Richard Morin made a 12-foot-tall monster costume with red eyes (shown at right) and walked around all night. The monster was a big hit with the kids, and everyone wanted a picture with him. (Right, Amy Poirier; below, Heather Morin.)

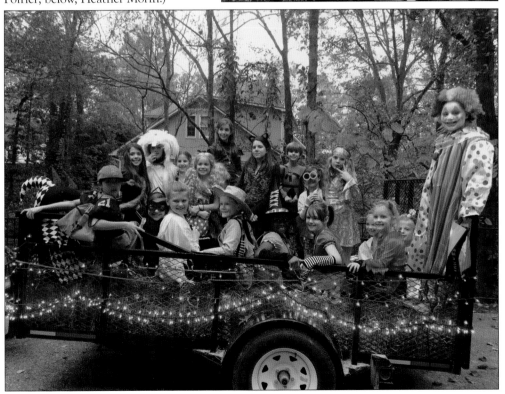

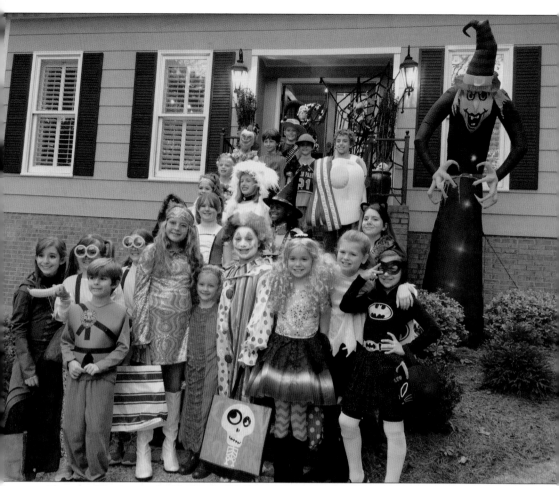

TRICK OR TREATING, 2015. A rainy Halloween night in 2015 brought out little ghosts and goblins and a few clowns and witches early in the evening. Halloween will hopefully always be a night of fun for both kids and adults in the Riverchase community. Pictured getting ready for a night of trick or treating in Lake Point Estates are, in no particular order, Jaden Englett, Tatum Englett, Cohen Englett, Avery Shaw, Ava Mudano, Harper Poirier, Hadley Carter, Madison Fairfax, Taylor Flicking, Katie Pate, Haley Pate, Kate Connell, Olivia Landess, Madison Brodneux, Campbell Whitehurst, Zoe Clements, Riley Harrelson, Charlie Clements, Brady Heath, Max Vinson, Chapman Blevins, and Collier Blevins. (Amy Poirier.)

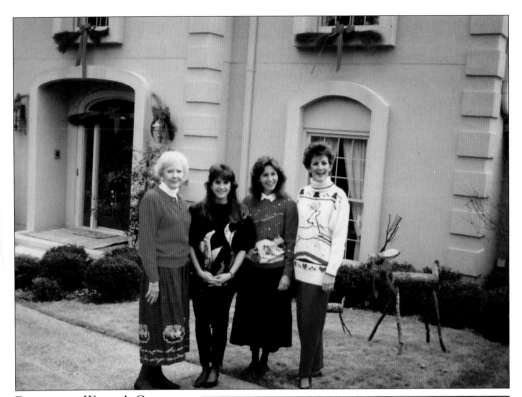

RIVERCHASE WOMEN'S CLUB CHRISTMAS TOUR. Each year, the Riverchase Women's Club hosts a Christmas tour of homes to benefit a charity. The proceeds from this tour benefited Magic Moments at Children's Hospital. Homes featured on the 1987 tour included those owned by Larry and Joanna Gibson; Eugene and Peggy Graham; Dan and Sue Doles; and Dennis and Diane Reid. Pictured above standing in front of the Graham home in 1987 are, from left to right, Peggy Graham, Beth Marsh, Terry Hooks, and Sally Headley. Christmas is always an exciting time in Riverchase, with decorating to do and social events to attend for a good cause. Pictured at right is Sandra McMahan's eye-catching Christmas tree from 2015. (Above, Riverchase Women's Club; right, Sandra McMahan.)

MR. AND MRS. SANTA CLAUS. Pictured in the late 1980s is longtime resident Nadine Hamilton, affectionately known as Mrs. Claus for over 20 years. Hamilton often played the role of Mrs. Claus at Riverchase Country Club along with her late husband, Jim. Santa and Mrs. Claus (aka Nadine and Jim Hamilton) are pictured here with Katie Hardekopf. (Pam Roberts.)

FIRST ANNUAL CANDY CANE RUN, 2004. This picture shows Dr. Howard-Fuqua (wearing candy-cane "ears") and her son Jacob at the finish line of the first annual Riverchase Elementary School Candy Cane Run. The one mile run/walk is held for parents and children to promote fitness and help raise money for the physical education department. (Riverchase Elementary School.)

BRIGHT TRADITION. These decorative light trees, pictured on Riverchase Parkway, are displayed throughout Riverchase during the Christmas season. The trees originated on Lakemoor Drive many years ago and became a popular tradition. Jan Skinner, a 30-year resident of Riverchase, remembers them fondly. Skinner's father, William French, pictured at right, made the original trees displayed on Lakemoor. Today, instructions for assembling the trees is printed each year in the Riverchase Residential Association newsletter. Over 70 trees have appeared in the Oaks section of Riverchase, and many more can be seen throughout the community. (Both, Jan Skinner.)

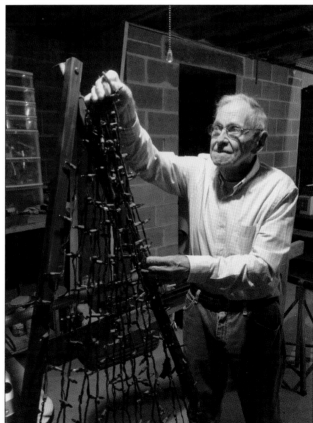

BIBLIOGRAPHY

Birmingham Public Library Archives.
Birmingham Rewound, www.birminghamrewound.com.
Christ the King Lutheran Church archives, www.ctklutheranbham.org.
Morris, Phillip. "Working with Not Against the Land." *Southern Living*, April 1978: 138–140.
Riverchase Country Club, www.riverchasecc.com.
Riverchase Women's Club archives.

About the Riverchase Women's Club

As the interest of the club expanded in the late 1980s, the Riverchase Women's Club directed its objectives to promoting charitable, civic, and social activities in the Riverchase community. Today, the club's work benefits multiple charities while working together to build a stronger community.

About the Author

ABOUT THE AUTHOR. Heather Jones Skaggs is a native of Hoover, Alabama, where she writes about the community in which she lives and works. Learn more about her at HeatherSkaggs.com. (Time Capsule Images Photography.)

DISCOVER THOUSANDS OF LOCAL HISTORY BOOKS FEATURING MILLIONS OF VINTAGE IMAGES

Arcadia Publishing, the leading local history publisher in the United States, is committed to making history accessible and meaningful through publishing books that celebrate and preserve the heritage of America's people and places.

Find more books like this at
www.arcadiapublishing.com

Search for your hometown history, your old stomping grounds, and even your favorite sports team.